ESKENAZI

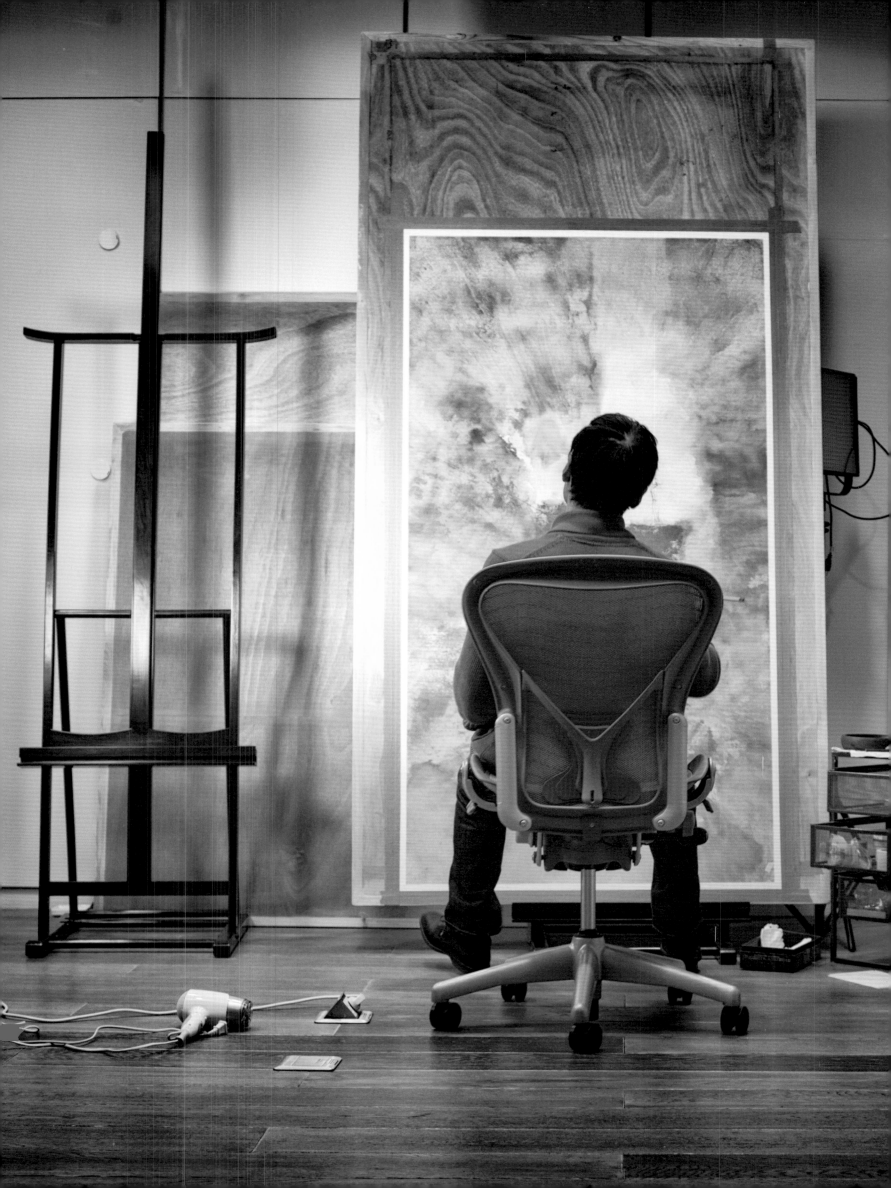

ESKENAZI

**Waterfalls, rocks and bamboo
by Li Huayi**

15 October - 15 November 2014

**10 Clifford Street
London W1S 2LJ**
Telephone: 020 7493 5464
Fax: 020 7499 3136
e-mail: gallery@eskenazi.co.uk
web: www.eskenazi.co.uk

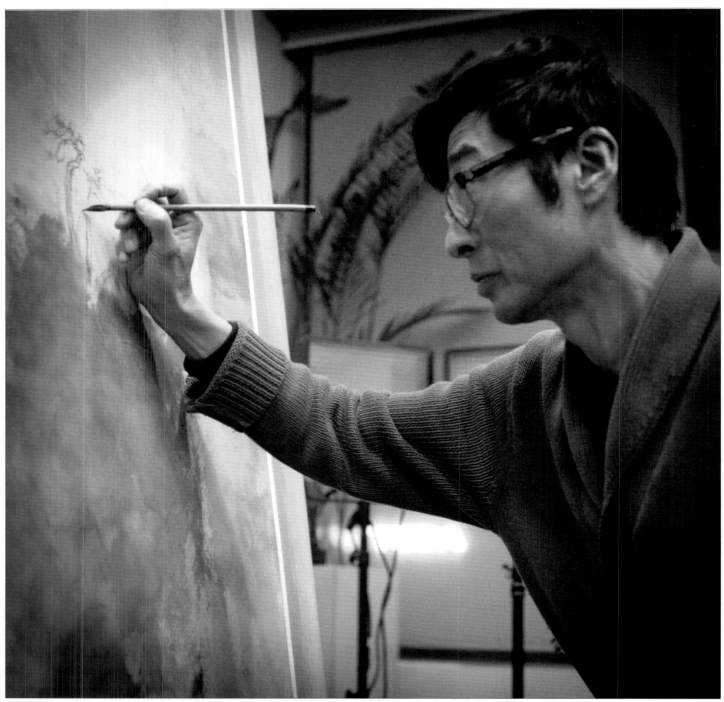
Photographs of the artist in his studio in Beijing, frontispiece, page 4, page 6 and page 73, by Daniel Eskenazi.

ISBN: 1 873609 36 1

Design and typesetting Daniel M. Eskenazi, London
Printed and originated by Colt Press Ltd, Witham

Foreword

It is a great pleasure for me to write that this is the fourth exhibition of Li Huayi's paintings we have held in the past seven years - one in New York and three in London. Souren Melikian's review of the first London show in November 2007 in the *International Herald Tribune*, 'A Master's Ethereal Visions, inspired by East and West', described it as 'one of those miracles one hopes for without really believing that they can happen'.

The eight paintings in the present exhibition are Li's latest work and again demonstrate those qualities that appeal both to the most refined and knowledgeable collector and the visitor who may wander into the gallery here and see the paintings for the first time. They are immediately accessible and at the same time reference a long tradition of Chinese ink painting that has occupied scholarly connoisseurs for centuries. The subject matter is evidently the natural world of rocks, trees, mountains, water and mist. This world is presented, however - particularly to those accustomed to viewing paintings of nature through the lens of the post-Renaissance Western tradition – in stylized, almost non-naturalistic fashion. This is despite the actual geography of certain regions of China being faithfully reflected or, in the rock and bamboo paintings, their forms being minutely recorded. Some aspects of the subject matter are brought to the fore, even exaggerated, others purposely obscured or left ambiguous. Li Huayi's technique is similarly a combination of the free – the wash of watery ink that is habitually the starting point of each landscape – and the controlled, in the detailed brushwork that completes the vision.

I would like to thank Dr Michael Knight, Asian Art Museum Foundation Curator Emeritus and Kuiyi Shen, Professor of Art History, University of California, San Diego, both long-time admirers of the artist, for the truly informative essays they have written specifically for this exhibition, Professor Shen providing both his Chinese and English texts. I am also grateful to Yi-Hsin Lin for translating Dr Knight's essay into Chinese.

This exhibition would not have taken place without Daniel Eskenazi who had many discussions in Beijing with Li Huayi on which form it might take and how the artist might find fresh sources of inspiration. As always, Daniel has designed and typeset a catalogue that is a worthy record of a beautiful exhibition.

Giuseppe Eskenazi

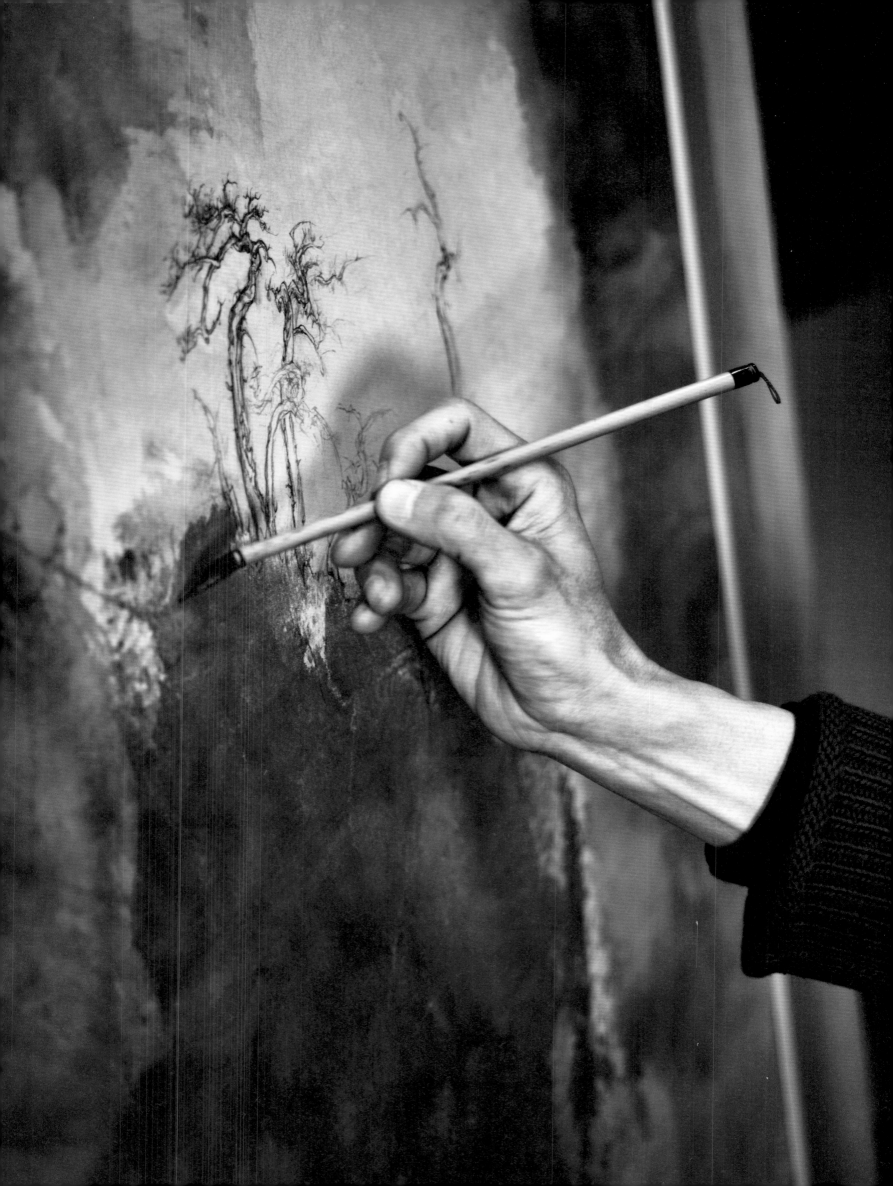

前言

我十分荣幸地书写此章，因为这次是本公司第四次举办的李华弌画展，在过去七年之中，相继而行，一次于纽约，三次在伦敦。2007年11月第一次伦敦展，由 Souren Melikian 先生主笔的简介，刊登在《国际先驱论坛报》上，标题是：大师的空灵愿境，灵感来自东西方，文中描述画展为'难以置信它的存在，可它是一个奇迹，一种希望'。

这次展出的八幅画，均为李先生近作，再次证明其画作的特质，既能对文雅饱学的收藏家产生吸引力，也有意外的惊喜来触动那些漫步进入画廊的访客。他们可以一览无余，从中领略悠久的中国水墨画技法，也正是数百年来文人墨客鉴赏之所在。画里题材多为大自然中的石头，树木，山峦，水流和雾霭。天地宏观，万物有序。然而，对于习惯用正宗文艺复兴的眼镜来衡量自然画法的西方人，这种表现形式大多属非自然风格。画展中有忠实反映中国某地区的地理特征，岩石竹林画是被精细模仿绘制的。题材中的一些方面是要突出表现的，甚至采用夸大渲染手法，而有些部分则刻意抽象化或含糊略过。李先生的绘画技巧，很像是一种自由与控制的结合体，每幅山水画都惯于用潇洒肆意的泼墨方式开始，而以细腻缜密的笔触来完成全景。

在此，我要向亚洲艺术博物馆基金会名誉馆长 Michael Knight 博士和沈揆一教授，表示衷心的感谢，他们都是李先生长期的崇拜者，专为本展联手合写的论文，信息丰富，内涵严谨。沈揆一教授还提供了中英对照文本。我同时要谢谢林逸欣先生，他为 Knight 博士的论文所做的中文翻译。

这次展览之所以成行，Daniel Eskenazi 厥功甚伟，他多次到北京找李华弌洽商具体细节，选择展览的形式，帮助艺术家寻找新的灵感之源。如同往昔，Daniel 主持图录的设计与排版，执着地将美丽的瞬间载入永久。

Giuseppe Eskenazi

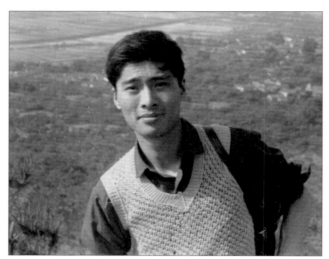

Fig. 1 Li Huayi during the Cultural Revolution period.

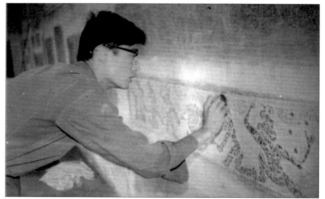

Fig. 2 Li Huayi at Han Dynasty tombs in Henan, 1974.
Courtesy of the artist.

In His Virtual World – The Recent Painting of Li Huayi
by Professor Kuiyi Shen

From as early as the 1910s, artists in Shanghai sought to develop cosmopolitan forms of art and cultural institutions that were suitable to the modern world into which the new republic had been born. New art schools and colleges, art societies and ateliers, exhibitions and journals disseminated the fruits of their efforts and, over the course of the period between 1919 and 1949, established a distinctive Shanghai artistic culture. As China's largest and most prosperous treaty port, Western forms of art such as oil painting and watercolors, as well as commercial art, flourished. Although the city was an important center for the mixing of European, American and Asian sojourners, it was equally significant from the early 1860s as a location to which people from all parts of China migrated. Artists who moved to the city brought their local styles, particularly those of Zhejiang, Jiangsu and Guangdong and in their interactions gradually produced a recognizable 'Shanghai style' of Chinese painting.

While some of the modern art programs established in the city emphasized Western forms of art to the exclusion of traditional Chinese painting and crafts, by the 1920s both kinds of art had become well established. Both oil painting and ink painting were exhibited in major metropolitan exhibitions, albeit with juries comprised of experts in the two different aesthetic modes. By the late 1920s it was not uncommon for Shanghai artists to be fluent in both ways of painting and the first National Art Exhibition of 1929 included examples by artists whose works were selected for both the Western-style painting category and the Chinese painting section. Just as many citizens of treaty port Shanghai were multi-lingual, speaking various Chinese dialects along with French, English, or Japanese, some artists worked simultaneously in various modes, ranging from ink painting, calligraphy and seal carving to oil painting, watercolors, drawing or commercial design.

Shanghai culture has thus been described as a hybrid one, but what does this mean? Was it in some way incompletely one thing or the other? Certainly not. For the most influential members of the formative generation of modern artists, those who emerged in the early Republican era, it meant mastery of more than one culture and the ability to range freely across different artistic worlds and, perhaps most importantly, the ability to make informed comparisons. They travelled and read widely, some of them spent years studying in Paris or Tokyo and they brought what they had experienced home with them. At the same time that they organized exhibitions devoted to modernist oil painting, expressionist prints and Chinese painting

in China, they took Chinese ink paintings to Paris, Berlin, Moscow and Rome, endeavoring to educate Western audiences in the beauties of the Eastern aesthetic tradition. By mid-century, the Shanghai cultural world was a rich and pluralistic one and one that presented almost insurmountable ideological challenges for the newly established People's Republic of China. How might such a complicated society, with such deeply rooted and varied cultural convictions, be re-educated in the principles of Chinese communism?

Li Huayi was born in Shanghai in 1948, the year before conclusion of the civil war that forced the government of the Republic of China into exile on Taiwan and resulted in the establishment of the People's Republic of China. His formative years were spent in the unique cultural, social and economic environment created by the new regime (fig. 1). On the one hand, restrictions on personal migration were implemented to accompany the conversion of private business and real estate to public property. The city's institutions were in a state of constant transformation, but the population was largely immobile. Essentially frozen in place, Shanghai's citizenry had increasingly little contact with the outside. On the other hand, the pluralistic, cosmopolitan society of pre-1949 Shanghai survived in the memories, habits and personalities of its adult population. Experiences of Paris, Chicago and Tokyo were transmitted vicariously to younger family members, friends and students, creating a plethora of vivid, if imaginary cultures, to which one might aspire.

At the same time, the new authorities sought to invent a new nationally unified culture, but veered from one 'movement' to another, as centrally mandated programs were tried out and then abandoned or modified. Socialist realist art was introduced into Shanghai's publishing industry and the city's cosmopolitan art schools, now considered to be hotbeds of bourgeois modernism, were moved out of the city and diluted by merging them with other less internationally-oriented institutions. A new and constantly changing Maoist culture was grafted onto Shanghai's pre-existing way of life. Many of the old art professors were left behind in the city, marginalized by the new system, but with their reputations surviving in the memories of fellow artists.

If the physical world in which young people of Li Huayi's generation grew up was almost static, their mental world was one of kaleidoscopic transformation. As a child, Li Huayi began studying ink painting with a family friend, Wang Chuantao (zi Jimei, 1903 - 1978). Wang was a bold painter

of the Shanghai school tradition, skilled in both landscape painting and bird-and-flower painting and the son of prominent artist, philanthropist and Buddhist Wang Zhen (*zi* Yiting, 1867 - 1938). The elder Wang made his fortune as a shipping magnate and the family enjoyed extensive business, religious and artistic connections in Japan. Wang Jimei had himself been an active exhibitor with art societies during Shanghai's cultural hey-day, from the 1920s until 1949 and had visited Japan with his father. Wang Jimei's mode of painting required sophisticated mastery of Chinese painting materials, especially ink and absorbent *xuan* paper. In addition to studying the loosely brushed ink painting of the Shanghai school tradition, Li Huayi later also studied Western-style painting with Zhang Chongren (1907 - 1998), who had trained at the Royal Academy of Arts in Brussels. Zhang was a multi-talented academic artist best known for his commemorative sculpture, but equally skilled at watercolor painting and figure drawing and completely fluent in French. There was no regular institutional place for this devout Catholic after 1949, but his capabilities as an artist and teacher were so well recognized that his publications on technical aspects of watercolor painting were standard texts and for a time he was permitted to run a private atelier at his home. Li Huayi's studies with Zhang Chongren trained him well in the technical skills of European painting.

Both of Li Huayi's teachers had been extensively involved in pre-war efforts to establish the place of Chinese art in the international art world. Thus, in his early art education, Li Huayi was an inheritor of Shanghai's cosmopolitan past and he naturally pursued the artistic vocabularies of both East and West.

If the Shanghai art world had reached a position of cosmopolitan equilibrium before 1949, the ideological requirements of the new regime effectively fractured it. In Li Huayi's formal schooling and particularly after the outbreak of the Cultural Revolution in 1966, the figurative iconography of Maoist art, not virtuoso flower paintings or watercolor landscapes, was the public persona expected of every painter, professional and amateur alike. Superimposed upon the splintered remains of the old art world, it created a kaleidoscopic imaginary that was comprised of incompatible visual fragments. By the time the Cultural Revolution ended, a change brought about by Mao Zedong's death in 1976, young artists were eager to move beyond previous limitations to develop new ideas about making art (fig. 2). The open-door policy initiated in 1979 by the Chinese art world opened up some possibilities, but overall the art world was slow to change. Moreover, this cultural ferment appeared to follow no particularly rational direction, but instead exposed eager Chinese to an explosion of exhibitions, books and articles on seemingly random topics in the history of art.

In 1982, Li Huayi emigrated to the United States to find an art world in transition from abstraction to post-modernism. During his graduate studies at the Academy of Art College in San Francisco, he began to concentrate on subtle abstract compositions, work unlike anything he had painted in China. A decade after landing in San Francisco, Li Huayi's artistic experimentation and transformation bore fruit. Perhaps given license by the concept of appropriation that was key to much of the post-modern art appearing in the 1980s and 1990s, he turned his attention to the classical masterpieces of Chinese landscape painting. In a visit to his studio one is likely to see full-scale reproductions of the great eleventh century landscape paintings, images of crashing waterfalls, towering mountains, delicate trees and visionary mists, works of breathtaking monumentality. Li Huayi is not simply inspired by them, he lives them and has so thoroughly penetrated them with his eyes, his heart and his mind that landscapes now emerge from his own hand and his own spirit.

His works of the 1990s were extremely compelling, combining a strong sense of compositional drama, something that one might associate with abstract expressionism, with landscape images that evoke, but never copy, the stunning scrolls of Li Cheng (919 - 967) (fig. 3), Fan Kuan (active 990 - 1030) (fig. 4) and Guo Xi (after 1000 - c. 1090). Li Huayi's careful study of the classics of Chinese and European painting, as well as the modern American practice of abstraction, has yielded paintings that are at once firmly rooted in the history of Chinese art and instantaneously meaningful to contemporary viewers. The solid pine, the mist that both divides and unites the mountain peaks, the overhanging cliff, the tree clinging to rocky precipices, all echo the most potent motifs of Northern Song painting. At the same time, a viewer who has spent time in San Francisco, where Li Huayi has lived for many years, will recognize with surprise that the delicate trees in his work do not come from ancient painting, as they first seem, but are those of the windswept northern California coast. The dreamlike contrasts of pale mist and dark mountain cliffs resemble works of the seventeenth century artists of the fantastic, most notably Wu Bin (1573 - 1620) and Gong Xian (1618 - 1689), who created bizarre images by injecting naturalistic effects of light or texture into completely impossible settings. The highly detailed constructions of trees and rocks in Li Huayi's paintings are convincingly naturalistic, but they are placed in impossibly dangerous mountain settings. Clearly imaginary, they are so powerfully persuasive as to seem like the rare dream image that one encounters, with the shock of recognizing the impossible in broad daylight (fig. 5).

In the earliest phase of his landscape painting, the 1990s, the window of Li Huayi's home studio

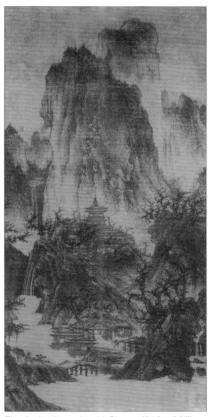

Fig. 3 Attributed to Li Cheng (919 - 967)
A Solitary Temple Amid Clearing Peaks,
Northern Song Dynasty (960 - 1127),
Nelson-Atkins Museum of Art.

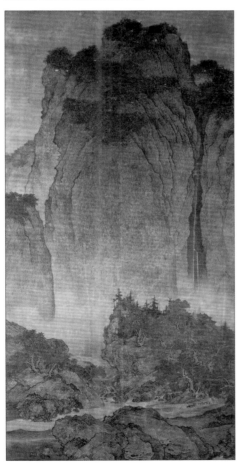

Fig. 4 Fan Kuan (fl. early 11th c.),
Travelers Among Mountains and Streams,
National Palace Museum, Taipei.

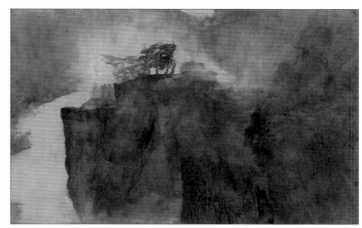

Fig. 5 Li Huayi, *Trees on the Mountain Top,* 1993 - 1995,
Yiqingzhai Collection.

overlooked the steep hills and valleys of coastal northern California. Like the photographs of Ansel Adams (1902 - 1984), but unlike most Chinese paintings, his landscapes contain no human figures. Instead, Li Huayi's landscapes are pristine, as though emerging from a purely spiritual state rather than the dustiness of the actual physical world. For him nature, as represented by the Song dynasty artists, is not like the contemporary world, sullied by industrial pollution. Li Huayi's unique vision may be said to embody a modern, almost romantic sense of wonder at the eternal beauties intrinsic to the natural world. Thus his work, so close to Song dynasty styles, compositionally and conceptually reflects a modern cosmopolitan vision.

He begins a painting by laying out the composition in large geometric areas of wash, seeming to follow the procedures of Western watercolor painting. The worlds created in Li Huayi's early paintings were stable and peaceful. He cut the cosmic order into fragments, which he reconstructed in unexpected ways. One could argue that his work was post-modern, in that it deconstructed the pre-existing structures of the world (and of the classical painting to which it refers). Li Huayi's works move us by persuading us that he depicts essential qualities of the cosmos, of which each painting gives us a fragmentary glimpse.

His success at unsettling or disturbing the viewer seems grounded in our shared conviction that the universe is indeed an orderly one and that both artist and viewer share this knowledge. This order, so well understood and recreated by the great landscapists of the eleventh century, has in the artist's work, slipped only temporarily out of our grasp, like an interrupted dream. As modern as they are antique, these paintings persuade us that they are part of a cosmic whole and that they exemplify a universal harmony whose absence from plain sight is an illusion.

His landscape paintings in the present exhibition, particularly those in the horizontal format,

are even more powerful. Their compositions are also unique. In one regard, they resemble a hanging scroll from which a horizontal slice has been taken. From another point of view, they telescope the viewer's eye back into deep space and then pull it sharply forward to the near distance, as might a handscroll by a Southern Song master such as Xia Gui (act. c. 1195 - 1230) (fig. 6). Yet, the landscape perspective is even more expansive, as though it were a photograph manipulated with contemporary optical technology. The eyes of the viewer are set in a kind of cinematic motion across the landscape, while the mountains themselves seem to jostle one another in space. The fragmentation of his earlier works is now pushed a step further, as Li resists the imposition of perfect quiet and instead imbues the peaks with a barely controlled sense of motion. As though challenging the imagination with virtual reality, or intervening in a world transformed by new visual technologies, Li Huayi's recent cliffs, peaks and trees resonate with movement to create a new kind of illusion.

Similarly, in this series in the present exhibition, the tranquil appearance of his earlier waterfalls is transformed into a turbulent force. Once again, suggestions of Southern Song principles and motifs – similar to Ma Yuan's (active c. 1190 - 1225) vivid album of waves in the Beijing Palace Museum – appear in what are essentially Northern Song compositions (fig. 7). If Li Huayi's earlier work presents the landscape as a pure and tranquil space, here the violence of the crashing stream seems to represent nature in the active process of purifying itself. Li Huayi often speaks about the importance of *qi*, which he loosely translates as energy, in his paintings, each work requiring a place for the *qi* to enter and a place from which it may exit. At the same time, he intends that the viewer will be energized by his paintings, as though electrified by the *qi* he has invited to pass through the landscape. There is always a sense of motion.

One final series in this exhibition, *Rock in Moonlight (I-III)*, approaches a new theme with the same intensity of focus that lies behind his landscapes. Here he has internalized every detail of a rare painting in the Shanghai Museum, a monochromatic image attributed to the tenth century master Xu Xi (886 - 975) and re-imagined the composition as something slightly different. The Shanghai Museum painting, which sets garden boulders, a wintry tree and a stand of thick bamboo against a gray wash background, bears the title *Snowy Bamboo* (fig. 8). In most Chinese painting, such a gray background wash indicates a snowy landscape. For Li Huayi, snow is of little concern. Instead, he seems to read the gray sky as the darkness of night and the brightness of the stone as the glow of moonlight. This is a rather radical re-reading of the Shanghai painting, but on closer inspection it is not easy to find any snow. One of Li Huayi's versions includes only bamboo, omitting

the dead tree, as does the museum's title. Another adds what seem to be autumnal lotus leaves. And the third depicts dried leaves of a kind similar to those found in another early painting, Cui Bo's *Magpies and Hare* of 1061 in the Palace Museum, Taipei (fig. 9). Thus, in his various paintings, he probes the possibilities of *Snowy Bamboo* both as a connoisseur, analyzing and appreciating it for what it is and as an artist, re-imagining what it could be. None of Li Huayi's works is a copy of the Shanghai painting, but one might call it an appropriation. He has adopted the basic compositional structure and the original's remarkable use of monochromatic ink. In each of his own works, Li Huayi portrays a different garden rock from Lake Tai, its smooth surface brightly illuminated with a slightly theatrical glow. In the Shanghai painting, by contrast, the uneven surface of the rock is covered with ink texture strokes and the foliage far less systematic or tidy. In this case, his kaleidoscope seems to have endlessly multiplied his image, but each tumbling fragment is slightly different from every other.

Li Huayi's painting reminds viewers of the beauties of nature admired by artists and collectors at the dawn of China's great painting tradition. On the other hand, his painting greatly expands the viewer's visual imaginary of the universe in terms suitable to both Chinese masters of the past and contemporary virtual culture. To paraphrase the words of the seventeenth century Chinese artist-theorist Dong Qichang (1555 - 1636), 'If one considers the wonders of brush and ink, then the actual landscape is not equal to painting.' The landscape that emerges from Li Huayi's brush and ink indeed surpasses that of the real world.

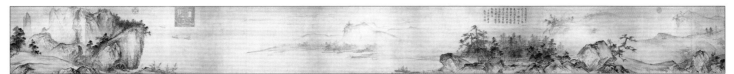

Fig. 6 Xia Gui (1195 - 1230), *Pure and Remote View,* National Palace Museum, Taipei.

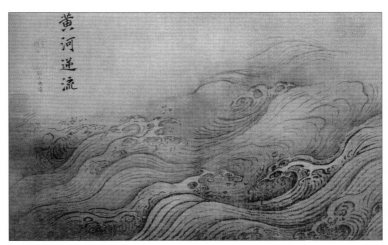

Fig. 7 Ma Yuan, *Twelve Scenes of Water,* Palace Museum, Beijing.

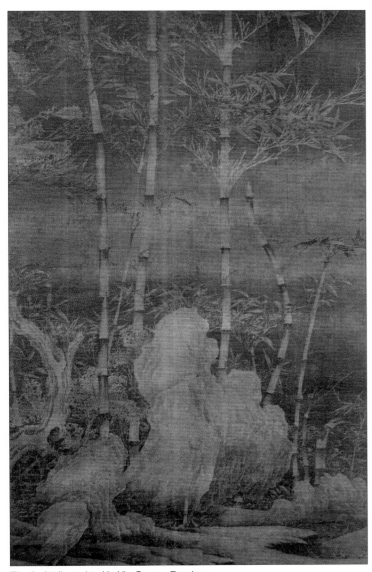

Fig. 8 Attributed to Xu Xi , *Snowy Bamboo,*
undated, Shanghai Museum.

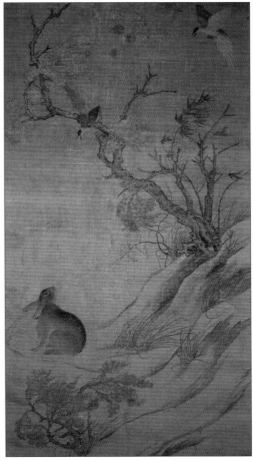

Fig. 9 Cui Bo, *Magpies and Hare,* 1061,
National Palace Museum, Taipei.

圖1　李華弌在文革時期。

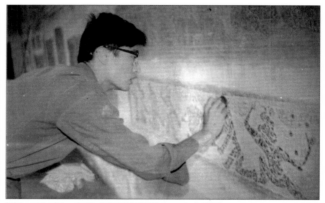

圖2　1974年，李華弌在河南漢墓中，本人存照。

在他的虛擬世界中 – 李華弍的繪畫近作
沈揆一教授

早在1910年代民國剛建立時，上海的藝術家們就開始嘗試創建更適於現代社會的國際化藝術文化機制。1919至1949年間大量湧現的新型藝術院校、美術社團、私人畫室、展覽和出版物充分地展現了他們努力的結果，也建立起十分俱有特色的上海藝術文化。作為中國最大也是最富裕的通商口岸，上海聚集了世界各地包括歐美和亞洲各國前來的居民。西方形式的藝術，例如油畫、水彩和商業設計，在上海也十分流行。同時，自1860年代開始從中國各地尤其是江浙和廣東來到上海的人口大量增加，其中也包括許多藝術家，他們把各地的繪畫風格帶入了這個都市。這些藝術家與本地藝術家之間的互動逐漸形成了極具特色的"海派"繪畫風格。

儘管一開始在上海創建的一些藝術學校強調西方藝術形式，沒有將傳統繪畫和工藝包括在教學課程之內，到1920年代時各種藝術的教學都已較均衡地發展了。在1920年代末，不少上海的藝術家都能自如地馳騁於不同的藝術領域。1929年第一次全國美術展覽中就有多位藝術家的作品同時入選於西畫部和國畫部。就像這座商業大都市中的許多市民常常能講好幾種不同的中國方言，也許還有法語、英語或日語，不少藝術家也能同時進行傳統水墨畫、書法篆刻、油畫、水彩、素描，甚至商業設計的創作。

上海的文化因而被形容為一種混雜的文化，但是這意味著甚麼呢？是否它就是一種不完整的文化呢？當然不是。對於在民初現代藝術創建期成長的這一代中最有影響的那些藝術家來說，它意味著對多種文化的瞭解和掌握，有能力自由地穿行於不同的藝術領域，或許最重要的是有能力對這些不同的文化藝術觀念和形式加以比較。他們周遊各國，博覽群書，許多人在巴黎或東京學習多年，并將他們在國外的體驗帶回國內。同時他們還在國內組織各種現代主義油畫、表現主義版畫和傳統國畫的展覽，并將中國的傳統水墨畫帶到巴黎、柏林、莫斯科和羅馬，力圖以東方的審美傳統教育西方的觀眾。至二十世紀中葉，上海的文化界已是一個十分豐富和多元的實體，這對於新成立的人民共和國形成了一種難以對付的意識形態方面的挑戰。這樣一個有著根深蒂固的而且多樣文化傳統的複雜的社會能如何在中國的共產主義原則下被再教育的呢？

李華弍於1948年生於上海。這是在國內戰爭結束、民國政府被迫退居台灣，人民共和國正式宣告成立的前一年。他是在新政權所創建的獨特的文化、社會、和經濟環境中成長的。（圖1）一方面隨著私人企業和產業的公有化，城市的機制發生著不斷的變化，但是戶籍制度的強化使得人口的流動變得困難。這座曾經吸引了全國乃至全球的冒險家樂園似乎漸漸地被邊緣化為地方一隅。另一方面，1949年前那多元、國際化的社會仍然留存於這座城市的成人們的記憶、習俗和個性裡。早年在巴黎、芝加哥和東京的經歷仍有意無意地傳遞給年青的家庭成員、朋友和學生，激勵了一種生動的文化想像。

同時新政府也試圖建立一種新的統一的國家文化。但是隨著一波又一波的政治運動，推動的政策不斷地轉向或被放棄。隨著蘇聯的社會主義現實主義藝術的引入，原有的十分國際化的藝術學校被認為是資產階級現代主義藝術的溫床而被逐出這座城市，或與其他一些學校合併而加以稀釋化。一個不斷變化的新文化被嫁接入上海先前存在的生活方式。許多留在這座城市的老藝術教授在新的體制下被邊緣化了，但他們的聲譽仍然留在年青一代藝術家的記憶中。

如果說李華弍這一代年輕人在其成長的周遭物質世界很少有甚麼變化，他們的精神世界卻仍如萬花筒般地多彩。李華弍年少時就隨他家庭的朋友王傳燾（季眉，1903－1978）學習水墨畫。王季眉是一位傳統的海派畫家，擅長山水和花鳥畫，也是著名的海上名人、畫家、慈善家、社會和宗教活動家王震（字一亭，1867－1938）的兒子。王震早年為日本船運公司作買辦開始發跡，同日本的商業、宗教和藝術界都有著廣泛的聯繫。王季眉自己在1920至1940年代上海文化最活躍的時期就參加各種藝術團體，籌組展覽，并隨父親出訪日本。王季眉的畫風需要對中國傳統繪畫技法和材料精確掌控，尤其是對墨和易吸水的宣紙的把握。李華弍除了學習海派傳統的大寫意水墨技法外，還跟隨曾留學於布魯塞爾比利時皇家美術學院的張充仁（1907－1998）學習西方美術。張充任是一位多才的古典藝術家，以他古典寫實風格的雕塑聞名，但也擅長素描人像和水彩，還能說流利的法語。1949年後的政治氛圍對這位虔誠的天主教徒關上了常規的院校教學大門，但是他作為一位藝術家和教師的才華沒有完全被泯滅，他著述出版的水彩技法仍是學校基本的教材，在一個短時期裡，他還被准許在家裡開設私人的畫室。隨張充仁的學習使得李華弍對西方繪畫的技法有了很好的瞭解。

李華弍的兩位老師都在戰前廣泛地涉入了在國際藝壇建立起中國藝術的地位的各種努力。因此，在他早年的美術教育中，李華弍就已是上海國際化藝術的繼承者，很自然地追求東方和西方兩種不同的藝術語言。

如果說上海的藝術界在1949年前已經取得了一種國際化的平衡狀態的話，之後在意識形態上的強化則很有效地將其摧毀了。在李華弍的正式學校教育中，特別是在1966年文化大革命爆發後，革命的人物形象，而不是用於藝術鑑賞的花鳥畫或山水畫，是當時每位不管是專業或業餘的畫家所期待加以描繪和創作的。這些新的形象和各種舊藝術所殘留的碎片，無不相容但又都存在，在年青的李華弍腦中形成了一個多棱的視覺想像的萬花筒。1976年毛澤東去世，十年的文化革命終於結束。年青的藝術家們急切地想打破過去的政治限制和禁忌并發展藝術創作的新觀念。（圖2）1979年開始的經濟發展開放政策也為中國的藝術界開啟了一些新的可能性，但是整個藝術界的變化還是很緩慢。此外，這種文化上的發酵似乎沒有一個明確和理性發展的方向，而體現在大量展覽的湧現和書籍的出版，以及零散的有關美術史的討論。

1982年，李華弍移居美國，看到了從抽象主義藝術向後現代主義藝術的轉變。他在舊金山藝術學院研究生院學習的時候，開始專注於微妙的抽象構圖，創

作與他在中國時畫的完全不同的作品。在舊金山生活了十年之後，李華弌的藝術實驗開始開花結果。或許對許多在1980和1990年代出現的後現代藝術來說，挪用的觀念是十分關鍵的。李華弌也將他的關注點轉向中國古代山水畫的經典作品。去訪問他的畫室，人們可以看到牆上掛著許多十一世紀山水畫大師作品的原寸複製品。畫面中飛流直下的瀑布、高聳的山峰、精細刻畫的樹木和瀰漫的濃霧，展現了紀念碑似的震撼力。李華弌不僅僅是受它們的激勵，他和它們生活在一起，以他的眼睛和心靈充分地感悟它們。現在這些山水都從他自己的手和心靈中走了出來。

他1990年代的作品就極其俱有力量，結合了強烈的戲劇性構圖和中國古代山水畫的意象，前者容易令人聯想起美國的抽象表現主義方法和結構主義的觀念，後者則是受到宋代大師李成（919－967）（圖3）、范寬（活躍於990－1030）（圖4）和郭熙（約1000－1090）作品的啓發。李華弌認真研究中國和歐洲的古典繪畫，對美國現代抽象藝術也有實踐和研究，使得他的畫在堅實地根植於中國的繪畫歷史的同時令當代的觀眾也即刻產生共鳴。不論是山頂的青松、環繞山巔的雲霧、懸崖峭壁或是盤桓其上的一草一木，都反映了北宋山水中最具表現力的意象。同時，觀眾如果同李華弌一樣在舊金山居住過，就會發現他作品中的樹木輪廓並非來自古畫，而是取材於加利福尼亞北部海岸受風侵襲的樹木。（圖5）灰色的雲霧與模糊的峭壁構成朦朧的對比，類似17世紀非常著名的藝術家吳彬和龔賢的作品。兩位畫家都在完全非寫實的背景中加入了自然的光線效果和紋理效果，創造出一種奇異的意象。李華弌作品中那些十分具體地刻畫的樹木和岩石十分自然主義，但它們被置於現實中難以存在的危岩之上。它們無疑是出於想像，但又似乎俱有那麼強烈的說服力，以至於帶給人們在大白天遇見夢中景象時那種難以置信的震撼效果。

1990年代早期他創作山水畫時，他畫室的窗外是加利福尼亞北部高聳的山谷和深陷的峽谷。李華弌的山水畫中從來就沒有人物，更像著名攝影家亞當斯（1902－1984）的風景照片，而不像大多數中國畫。他的山水是那麼地純淨，似乎完全出自於純淨的精神世界，而不是來自現實的塵世中。對他來說，自然就像宋代畫家所描繪的，而不是現今遭受了工業污染的境況。李華弌對自然獨特的觀照可以說體現了對自然界內在的、永恆的美的一種帶有浪漫情調的現代想像。因此他的作品在風格上與宋代的山水那麼接近，但在構圖和觀念上反映了一種現代的全球性視角。

每每作畫之初，他會用大筆進行佈局，很像西方水彩畫的創作過程，但又出奇地別出心裁。他先將自然景象的序列分割打亂，然後以出人意料的方法重組畫面。我們或許可以說他的觀念是十分後現代的，因為他完全解構了我們世界以及他參考的中國古典繪畫中現存的結構。但是他的作品之所以動人，是因為他使我們相信他的作品再現了宇宙的本質，而他的每一幅作品則向我們展現了其中一部份不完整的碎片。

李華弌的作品能夠成功地擾亂觀眾的心靈，是基於我們都相信宇宙原本就是一個有序的世界，這是藝術家和觀眾所共識的。這個在十一世紀的山水畫傑作中得到充分的理解和再現的有序世界在李華弌的作品中似乎暫時地逃出了我們的掌控，好像一個被打斷了的美夢。這些亦古亦今的作品似乎要說服我們，它們只是宇宙整體的一部份，但是代表了宇宙的和諧。我

們平常之所以看不見這個和諧的有序世界，乃是因為受到了錯覺的干擾。

他在這次展覽中的作品，尤其是那些橫幅的作品，甚至更有震撼力。它們的構圖也是十分獨特的。從某種意義上來說，它們很像傳統的水平構圖的橫卷軸畫。但從另一角度看，它們引導觀者的視線進入深處的空間，又急劇地拉回至近處的景象，使人想起南宋畫家夏圭（活躍與1195－1230）的畫面（圖6）。但他的畫面景物的透視則更為開闊，好像一幅用當代光學技術處理過的照片。觀者的眼睛就像電影攝影鏡頭在畫面上移動，畫中的景色似乎在畫面空間中爭相出入。李華弌早期作品中的碎片感現在又更進了一步，他不再強調那種完美的寧靜感，而賦予畫面中的群山一種不加以控制的動感。或許是以虛擬的方式向人們的想像力進行挑戰，亦或介入了一個被新的視覺技術改造了的世界，李華弌最近畫中的山峰、峭壁和樹木由於這種運動感而創造出一種新的幻覺。

同樣，在這次展覽中，他早期作品中瀑布的那種寧靜特質也轉變為一種洶湧的力量。南宋繪畫的觀念和主題——類似於現藏北京故宮博物院的馬遠（活躍於1190－1225）水紋冊頁（圖7）——出現在北宋的山水構圖中。如果說李華弌早期的作品將山水表現為一個純淨安寧的空間，最近這些畫裡洶湧奔騰的瀑布似乎表現了大自然積極自我純淨的過程。李華弌常常強調"氣"的重要性，在他的每幅畫中都有"氣"的出入之處。同時他也希望觀者能夠從他的畫中體會和吸取到貫穿在他山水中的"氣"。這裡始終意味著一種運動的感覺。

這次展覽中的另一個系列，竹和石，則探討了另一個新的主題。這裡他採納了現藏於上海博物館、被

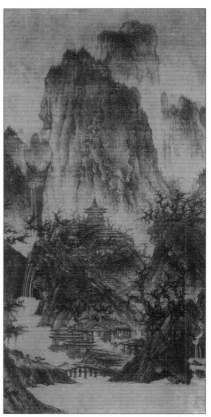

圖3 傳為李成 (919 - 967)，〈晴巒蕭寺圖〉，北宋 (960 - 1127) 納爾遜藝術博物館。

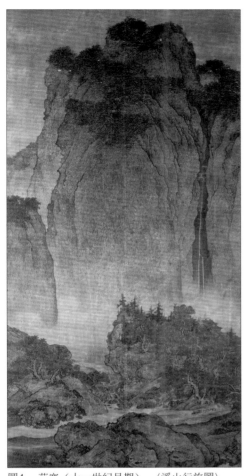

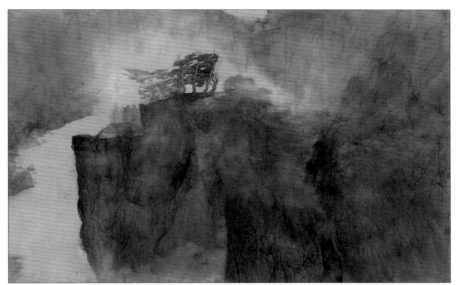

圖5　李華弌，〈山頂樹〉，1993－1995，怡情齋藏。

圖4　范寬（十一世紀早期），〈溪山行旅圖〉
台北故宮博物院。

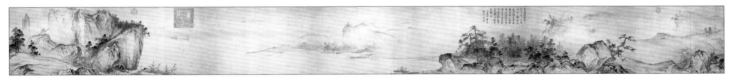

圖6　夏圭 (1195－1230)，〈溪山清遠圖〉，台北故宮博物院。

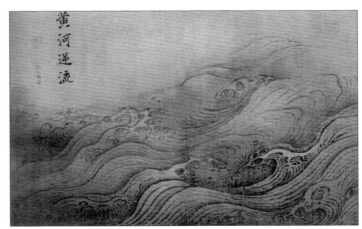

圖7　馬遠，〈水圖〉，北京故宮博物院。

認為是十世紀畫家徐熙（886－975）的一幅單色水墨畫中的所有細節，但在構圖上作了些微的更動。（圖8）上海博物館的這幅畫表現的是庭園一隅，前景幾塊石頭，左邊一棵枯樹，以及在淡墨渲染的背景中的幾枝竹子，取名為《雪竹圖》。在許多中國的古代繪畫中，像這樣用淡墨渲染的背景常常為描繪雪景。但對李華弌來說，雪可能并不是他的關注點。他似乎將灰色的背景解讀為夜色的黑暗，明亮的石頭或許是月色的照耀。這可能是對上海的那幅藏畫的一個相當大膽的詮釋，但是如果細看徐熙的畫，也確實不容易找到任何雪的描繪。李華弌系列中的一幅只有竹石，去除了枯樹的刻畫。另一幅似乎加上了對秋天荷葉的描繪。第三幅中枯葉的刻畫很像另一幅藏於台北故宮、崔白畫於1061年的《雙喜圖》的。（圖9）因此，李華弌在不同的構圖中對《雪竹圖》的探索，既作為一位鑑賞者對其分析和欣賞，也作為一位藝術家對其加以可能的想像。沒有任何一幅李華弌的作品是對上海博物館的《雪竹圖》的直接摹仿，但是人們可以稱其為一種挪用。他採用了基本的構圖結構和原作中單色水墨的運用。在他的每幅作品中，李華弌描繪了不同的庭園太湖石，石頭光滑的表面賦予略帶劇院照明效果的亮光。相對比，在上海的《雪竹圖》中不平的石頭表面賦有墨色皺筆，簇葉的描繪也遠沒有李華弌的那麼規則和有條不紊。這一次，他的多棱萬花筒似乎無盡地增添著他的畫面形象，但每一個滾動的碎片都稍稍不同。

李華弌的繪畫無疑使得觀眾想起了在中國偉大繪畫傳統形成期藝術家們所欣賞的自然的美。另一方面，無論是就中國古代大師的作品或是就當代的虛擬文化，他的繪畫都極大地擴展了觀眾對大千世界的視覺想像力。17世紀的學者和畫家董其昌曾說過一句話，大意是如果我們懂得筆墨的神奇力量，我們就知道，真正的山水永遠無法同畫中的山水相比。李華弌筆墨中作出現的山水實際上已超越了現實的世界。

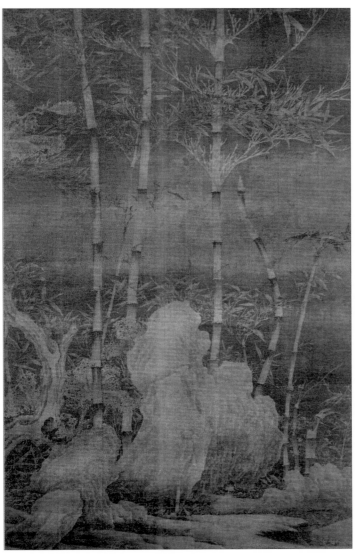

圖8 傳為徐熙，〈雪竹圖〉，上海博物館。

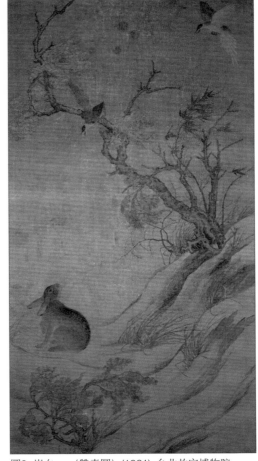

圖9 崔白，〈雙喜圖〉(1061)，台北故宮博物院。

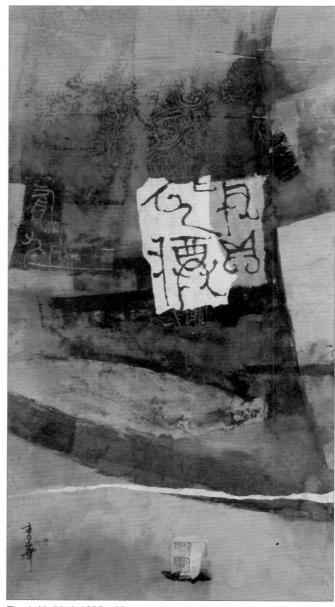

Fig. 1 Untitled, 1982 - 83, vertical scroll, ink and color on paper, 114.3cm x 64.1cm, Guanyuan Shanzhuang Collection.

New Developments in Paintings by Li Huayi
by Dr Michael J. Knight

When he first came to the United States in 1982, Li Huayi was thirty-four years old and had been making a living in China as an artist for a considerable period of time. Already an adult, he faced an artistic environment that was entirely different from what he had faced previously; one for which his background and artistic training provided little support. At that time China was emerging from the Cultural Revolution and there was no private market for art, the government had long since supplanted that role. For much of his life to that point, training and practice was at government institutions where artists received a stipend; while some were expected to teach, their works did not need to sell and public acceptance of their art was secondary to meeting the demands of the government. In contrast, in the United States he faced an artistic environment in which critical acclaim and market forces play a vital role. When he arrived, Li had no access to the established infrastructure and no clear market for his art; he initially made his living by delivering produce to a major hotel chain. This is a familiar state of affairs; almost every artist has some story of making a living in whatever way possible before becoming successful.

During these first years in San Francisco, Li Huayi did continue to produce paintings in a style he had been developing before leaving China. Based on his interest in China's past, these paintings were in a style loosely inspired by works found at the Dunhuang caves.[1] Years later he is somewhat embarrassed by these paintings; they are decorative, colorful and, for him, relatively easy to produce. He was discovered by Roberta English, who operates a gallery in Sausalito, California and in 1982 had an exhibition featuring his Dunhuang style works. It was a commercial success which enabled him to make a living as an artist, to become an artist full time. As is often the case, commercial success allowed him to pursue his art and freed him from the burden of having other employment. It also allowed him to begin to explore artistic issues.

Li Huayi also faced a definite risk in his commercial success. The temptation to stay with a commercially viable product and not push artistic boundaries must have been great; after all, if the choice is between making art that is commercially viable and delivering groceries, then the obvious choice is to create the art even if it is not the most satisfying or challenging. Here the market can work against an artist; a possible patron will want a Li Huayi like the ones he/she is already familiar with whereas something radically new might not be acceptable. Li Huayi has faced this challenge, the dilemma between being commercially successful and continuing to push his artistic boundaries, to create new artistic challenges for himself, for his entire career.

He could have continued to paint in this fashion for a number of years, but clearly found it less than satisfying and went on to explore other options. Instead, fueled by artistic drive and curiosity and supported by the financial resources provided by his commercial success Li chose to enter the Academy of Art in San Francisco. There he found himself facing conflicts between his fascination with the theory and practice of post-World War Two painting in the United States, the post-modernist theories and approaches taught at the Academy of Art and his background and training in China. Post-war American art attracted him intellectually and visually, yet he found the actual practice of these styles unappealing due to the negative feeling he had developed about practicing Western art during the Cultural Revolution. His readings of post-modern theory and living in the United States heightened his desire to be 'contemporary' and increased his awareness of the complexities of that term. His own philosophy on being a contemporary artist reflects this background: 'In my mind, being contemporary is not about being fashionable or doing the most current thing. It is not about doing installation art simply because it is the most avant-garde, or performance art because it has taken installation art's place as the most fashionable. The word 'contemporary' is very personal, your own feeling, but also relevant to your time and place.'[2]

While many of his generation continued to explore other mediums, many based on Western traditions, Li Huayi was in the vanguard of those who explored ink, the most traditional Chinese medium. His first attempts to find links between the Chinese art tradition and Western theory and practice, done while still a student at the Academy of Art, consisted of experiments with abstract forms in ink, at times combining painting with collage. His training and interests led him to focus on the abstract patterns traditionally found on borders of ceramics and other decorative arts over a background of spontaneously applied ink (fig. 1). This is a technique he continues to employ in his paintings today.

In addition to his reading of Western art theory and interest in post-war Western art developments such as abstract expressionism, there were a number of other sources of inspiration for this style. As mentioned elsewhere, Li Huayi was and continues to be inspired by the works of Zhang

Daqian (1899 - 1983) who was well known for his splash ink landscapes (fig. 2). About Zhang, Li Huayi has said: 'When I view a Zhang Daqian painting, I think, "This is a twentieth century person and what he is doing is so Chinese; yet it is also a new kind of painting at an international level.' I want the viewer to feel the same way about my [twenty-first century] paintings.'[3]

Collage, while certainly a modern Western technique, also had its Chinese precedents in *bapo* ('eight brokens'), a technique practiced in Shanghai and other cities in the late nineteenth and early twentieth century and one with which Li Huayi was familiar. Many of his abstract forms were based on border patterns found in Chinese decorative arts. These works were not as successful commercially as his Dunhuang style paintings, which he continued to produce, but provided him with critical acclaim and led him to have his first one person show, at the Pacific Asia Museum in Pasadena. This exhibition, curated by David Kaminsky, featured a combination of his Dunhuang-style paintings and his abstract works. His abstract paintings in particular caught the attention of Michael Sullivan, a leading scholar of Chinese painting, who saw in him an emerging talent. Clearly, Huayi had not found his unique artistic voice and was practicing two very different styles, one figural, based on an ancient Chinese Buddhist tradition and commercially very successful, the other combining ink, abstraction and collage, clearly impacted by Western concepts and receiving critical success. He continued to explore variations of these styles for much of a decade.

By 1992 Li Huayi had reached an artistic cross-road. He was well trained in traditional Chinese painting and had mastery of the techniques of brush and ink. He had also developed a commercially viable style based on ancient Buddhist paintings from Dunhuang. He was aware of and conversant with Western art theory and principles and was skilled in a number of Western techniques, including collage and oil painting. Yet, for a variety of reasons he chose to reject each of these genres as his final artistic statement. He rejected his style based on Dunhuang paintings, commercially successful but lacking artistic challenge and meaning. He rejected Western techniques due to his experiences during the Cultural Revolution and his desire to find his own expression based on something uniquely Chinese. His economic success and training in post-modernist theory allowed him the freedom to seek his personal artistic voice.

As mentioned elsewhere, Li developed a style inspired by the monumental landscapes of the Northern Song dynasty (960 - 1279). This was possible due to his greater maturity and confidence as an artist and also due to an audience and market that had increased sophistication and awareness of Chinese art traditions (fig. 3). In choosing to create landscapes, Li reversed the trend of many contemporary Chinese artists, going from abstraction to landscape rather than the other way around. He was criticized for this move, with many of his colleagues and critics stating that it is impossible to be 'contemporary' while practicing a style inspired by paintings more than a thousand years old. This was intentional, both in terms of post-modern theory and in the fact that this was a style and a period to which he found he had personal and artistic connections. He is extremely well-read in the literature of the period. These works have been very successful, as a personal artistic expression, critically and also commercially. He has had solo exhibitions at major institutions, been included in a range of contemporary ink shows, etc.

Northern Song landscapes tend to be large in scale and concept and detailed and time-consuming in execution; they have long been recognized as the pinnacle of Chinese landscape painting and the few existing works are considered national treasures. This point was impressed upon Li Huayi while he was in his teens. However, very few artists since the end of that dynasty have had the patience to practice this technique or the skill to capture their essence. Again Zhang Daqian is among the few exceptions, though his forays into this style often took the form of forgeries.

The importance of process to and for Li Huayi cannot be dismissed. While much of contemporary theory and practice is conceptual and the direct presence of the hand of the artist is not considered to be of primary importance, Li Huayi has chosen to work in a form and style that requires a great deal of technical skill. He loves the process of creating his works and has been known to say that he finds refuge from the worries and challenges of day-to-day life in it. The philosophical debates and analysis that occupy so much of the art historian or the art critic have little bearing on what he does once he begins to paint; while they are important to him in the conceptual phases of creating a work, they fall into the background as he begins to paint and he loses himself to the act of creation.

Li does not produce many works in a year and one gets a sense that a major challenge for him comes as a painting nears completion. What is enough? When is the appropriate time to end the pleasurable activity of painting and call the work complete? However, he does know the limits, when to stop. He makes a clear statement that there comes a point in every work when it is evident to him that it is complete, when even one more stroke is one too many. He states: 'I work one line at a time; one of the biggest issues is in the correct grouping of lines. If even one line in any area of the painting is not good, it will ruin the area and thus the entire painting.' He defines bad brushwork as lines that are not elegant, or move in the wrong direction, not in the correct direction for the form being created but also in an abstract sense. A good

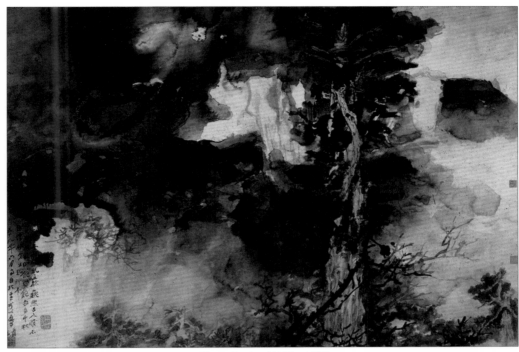

Fig. 2 *Deity trees (shenmu) in Taiwan*, by Zhang Daqian (1899 - 1983), dated 1970, ink and color on paper, H. 151.4cm x W. 211.8cm, Asian Art Museum of San Francisco, B73D4.

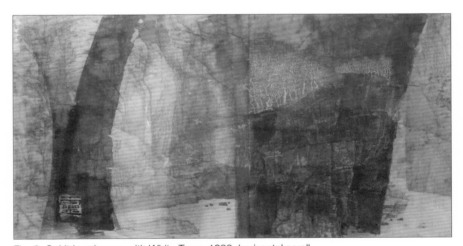

Fig. 3 *Spirit Landscape with White Trees*, 1993, horizontal scroll format, ink and color on paper, 66.0cm x 124.5cm, Yiqingzhai Collection.

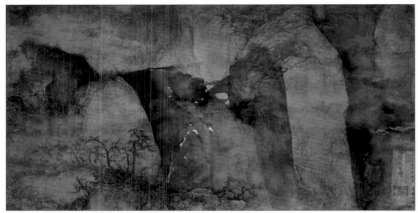

Fig. 4 Landscape, 2003, horizontal scroll format, ink and color on paper, 67.9cm x 128.3cm.

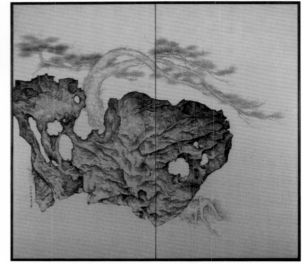

Fig. 5 *Rock and Pine,* 2008, 2-fold screen, ink on paper with gold ground, 185.0cm x 170.0cm.

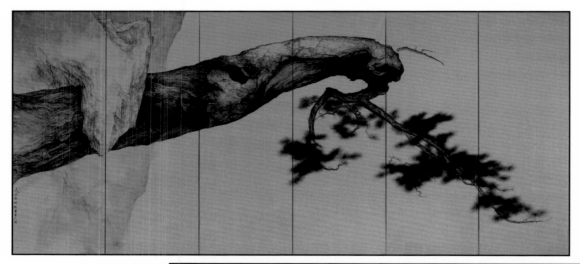

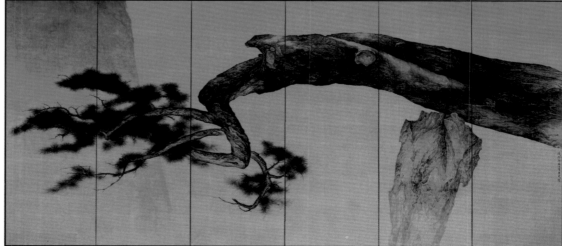

Fig. 6 *Branches of Pine with Rocks,* 2008, pair of 6-fold screens, ink on silk with gold ground, dimensions of each screen 382.0cm x 176.0cm.

line created with good brush touch but wrongly placed is still not good. Everything requires correct technique. In this way his painting reflects his personality, he strives for the elegant, not the pretty; he insists that his brushwork be correct to form and composition, not to decorative appeal. According to him, a technically accomplished brushstroke can be ugly if it is unnecessary.

As his study of landscape techniques has continued, Li Huayi has set himself a number of artistic problems and challenges. He states that taking a new idea from conception to finished product is a deliberate process that takes time. He needs a preparation stage and finds he cannot be successful if he is in a hurry: 'To be successful at being spontaneous, you need to be prepared to know what might work, when something is going in the right direction.'[4] Increasingly he tends to explore his themes through a series of works, not just the single landscape. In each series he is looking for 'something I have never done before, something that is new in the idiom of ink painting.'[5] He approaches these challenges in a deliberate fashion, spending as many as two or three years in developing the concept and in mental and artistic preparation. The results can be seen in series of related paintings devoted to the exploration of a particular challenge. Two such series are presented in this exhibition. They are discussed below.

His efforts were rewarded and encouraged by the success of an exhibition of these landscapes held at Kaikodo in New York in 1997. The works were well received critically and by the market. The response gave him confidence to continue to explore his new vision and he has stayed with these forms ever since. These landscapes clearly show the traces of his abstract works but with a much greater emphasis on brush touch. The larger forms are created by brush wash, like his earlier abstract works, but with details built up in painstaking layers of small strokes. These were stark landscapes devoid of human form, a reflection both of the painter's artistic interests and his concerns for the natural environment.

Critical success also came with the exhibition *Monumental Landscapes of Li Huayi*, hosted by the Asian Art Museum in 2004. By that time Li had been creating landscape paintings for over a decade and his approach was beginning to 'gel'. The catalogue that accompanied the exhibition was the result of a series of long and enjoyable discussions between the artist and this author which resulted in seventeen hours of tape. These discussions clearly demonstrated that Li was conversant with contemporary art theory and that it had an impact on his paintings.

With both critical acclaim and success in the market, once again there was a risk that Li Huayi would settle into a routine and no longer continue to innovate or advance his art form. This has not been the case. Instead he has set for himself specific artistic challenges or issues and has pursued solutions to these issues by creating paintings in series. Many of the issues he has been exploring have been technical and abstract. They are also increasingly Chinese in their execution. An example is a series he was working on in 2003, of what he called 'dark paintings' (fig. 4). He has this to say about those paintings: 'The dark series is challenging: the application of thick, dark layers of ink is technically very difficult. Although I am painting landscapes, my concept is more abstract; I want to explore, to challenge my artistic capabilities, to take some artistic risk, stopping right at the edge of what can be done in this style.'[6]

If the dark series was a study in ink tones and contrast, another series he was beginning at that time was an exploration of the basic surface of a painting, in this case gold. Here some of his inspiration came from Zhang Daqian, though he was trying to do something very different. His experiments led him to purchase and create works on old Japanese gold screens which had not been painted and to have papers and silks custom made. He was not satisfied with a number of his early efforts and destroyed some of these works. He ultimately found two solutions, gold-colored silk and gold on paper. The results can be seen in a number of large scale works completed in 2008 (figs. 5 and 6). He states about working on silk: 'I still spread the ink, but the response is different [than with paper]. Ink does not dissolve into the surface as much as it does with paper and the results can be surprising. No matter how carefully the artist plans, the results will always be different.'

In addition to materials, Li Huayi has done a number of series experimenting with formats and differences in scale. The gold-colored paintings discussed above are examples of large-scale works. Here his approach is to focus on bold, simplified forms, with an emphasis on outline. Large areas of the surface are left untouched, setting up striking contrasts between the painted and unpainted areas. There is subtle brush touch in the painted details, making these works visually interesting both from a distance and close up.

He has also done a series of small format paintings, with a particular focus on the rigid fans common to the Northern Song painting repertoire. Since the fan paintings are small, the large bold forms of the screen are not appropriate; instead these works tend to be densely painted with a very refined brush touch (figs. 7 and 8). Each of the different shapes of these fans, round, oval and trapezoidal, presents a different compositional challenge. The content is also different with a narrative element in the form of architecture or even figures appearing in the small-scale works, while the large-scale works tend to present landscapes

or very large trees. He has even created a series of fans celebrating the twelve animals of the Chinese zodiac, something entirely different from his large-scale landscapes. One traditional composition he has discussed but not yet tackled is the handscroll.

While his formats are traditional Chinese ones, Li Huayi pushes the envelop in works like *Mountain Range with Receding Views* (fig. 9). Here he is exploring the screen format, but also presenting something new and different. Six panels painted with broad washes of ink serve as a backdrop for a hanging scroll with one of Li's intensely painted landscapes. The compositions are continuous, making this a single and very powerful work. Although there is no surviving example of a traditional work done in this manner, he does find literary references for the combination. This is also a new approach to the compositional tradition in Chinese landscapes of having 'host' and 'guest' mountains. Here the hanging scroll is the host, while the background mountain range serves as the guest.

The hanging scroll remains Li's most common format. He prefers large-scale works, stating: 'the scale is contemporary as is the fresh feeling, something new and different.' He is also painting now in an environment that is very different from what it was even ten years ago. Like many of his contemporaries who moved to the United States in the 1980s, Li Huayi now spends much of his time in China and many of his paintings are created in his studio in Beijing. An increasing percentage of the market for contemporary Chinese ink painting is now in China and Li has major patrons in Taiwan, Hong Kong and the mainland as well as in the United States and Europe. These Chinese buyers have become increasingly sophisticated and are clearly not put off by traditional formats and traditionally based explorations of contemporary themes.

As mentioned above, the current exhibition offers examples of two relatively new series: one on bamboo and rock in moonlight and one on landscapes with a new emphasis. In both, Li Huayi incorporates his experiences from previous series and also goes beyond the largely abstract technical issues he explored in them.

He describes the series of landscapes as a study on 'soft' in contrast to a series on 'hard' he is also working on. These are complex metaphysical terms related to the concepts of *yin* and *yang*, cornerstones of Chinese philosophy and thus he is exploring broader concepts, very Chinese, very traditional, yet in an entirely new way.

Li Huayi has created some paintings which appear to be 'soft'. However, this is technical: in what he calls their 'wrinkle technique,' the brushstrokes make up the forms of the mountain. These are landscapes shrouded in mist, but with

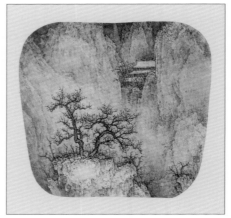

Fig. 7 *Pavilion in Winter*, 2007, trapeziform fan shaped album, ink on paper, 17.0cm x 18.0cm, Guanyuan Shanzhuang Collection.

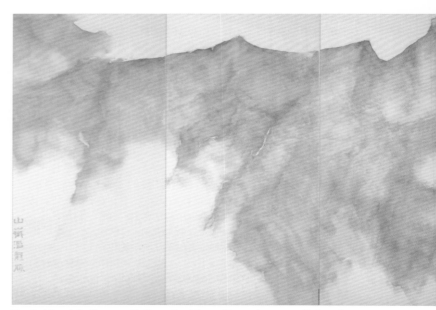

Fig. 9 *Mountain Range with Receding Views*, 6-panel screen with hanging scroll in front, ink and color on paper, dimensions of each panel: 91.5 x 183.0cm; dimensions of hanging scroll: 97.0cm x 201.5cm.

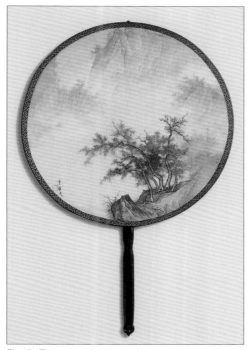

Fig. 8 *Trees on a Mountain Ledge*, 2007, circular fan, ink and color on silk, diameter, 26.0 cm, Guanyuan Shanzhuang Collection.

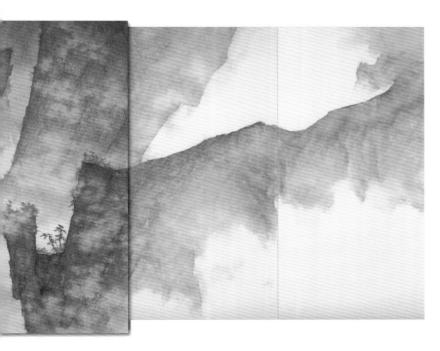

little water. The current series is a study on the philosophical as well as the physical 'soft' qualities of water. The concurrent series is an exploration of the 'hard', of rock where he attempts ' to capture the world, the cosmos in a rock.'[7] In 'hard' paintings, there is nothing soft, there are no trees and the presence of water is minimized. The forms are created with a strong brush touch, often using short, powerful strokes to outline the forms. The landscape forms are very well defined, seem to have more volume, their outlines appear sharp, almost brittle. The landscapes appear almost crystalline with none of the soft mists found in many of his earlier works.

In contrast, the paintings in this exhibition are all about water and soft mists. The first is a vertical hanging scroll with a massive waterfall dominating the center. It falls from a high cliff to a central cavity where a small group of trees is outlined against the mist created by its fall. It then continues to cascade through a rough channel into the foreground. The dramatic effect of the waterfall is heightened by the use of very dark, nearly black ink for the mountain forms. The power of the moving water is represented by a variety of long, ropy brushstrokes. It is certainly the most powerful representation of the qualities of water yet created by this artist.

The second painting in the series has a narrow horizontal orientation, almost as if it is a blown up detail from one of the artist's earlier landscapes. The lower ends of a number of narrow streams are shown cascading into a central cavity where the waters combine and fall over a cliff into the foreground. A small group of trees is highlighted against a misty background. Here the background is not as dark and the water is created in broader strokes of gray ink. The power of the water is reflected in the way it impacts the landscape.

The third of the group also presents a mountainous landscape in a horizontal orientation. Here the distinction between the water and the landscape forms begin to blur, almost as if the landscape is dissolving into, or uniting with, the cascading water. Cliffs created in light gray wash appear to continue into the distance until they disappear in the wet, soft atmosphere.

The second group of three paintings represents a new study by the artist on rocks. According to Li, in China there are two broad categories of kinds of rocks suitable for collection and display; the first is the *gong shi* which is a meditation rock intended for display on a table or other interior environment. The second is the *shang shi*, the type of rock often found in gardens. Both have their own elegance, but the *shang shi* also has elements of nature.

The portrait of the scholar's rock has become almost *de rigueur* for ink painters; most are doing portraits of *gong shi*, the type of rock often found on the scholar's table. These paintings usually consist

of a single rock with no context, just the white of the paper as a background. Li, in contrast, has provided an environment, placing the rock in a garden setting with bamboo at night. He combines the elegance of the *gong shi* with the sculptural qualities and overall environment of the *shang shi*. In this series, the rocks are presented in a bamboo garden under moonlight. He intentionally combines the sculptural qualities of the *shang shi* (garden rock) with the surface textures and qualities of the *gong shi* (table rock). In his mind, the *gong shi* is more about meditation whereas the *shang shi*, while also with its meditative qualities, lives within a context, an exterior garden environment. Another difference is in the amount of time required to complete the work. He says it might require up to two days to complete a portrait of a single *gong shi*, while one of this series of paintings might require two weeks. He has been creating paintings in which rocks are returned to their natural environment since the 1990s; an example is the 1997 painting *Rock Returned to Landscape: 2* (fig. 10).

In this series he has been inspired by *Snowy Bamboo,* a painting in the Shanghai Museum associated with the Five Dynasties Painter Xu Xi 徐熙. This continues his post-modernist trend of seeking inspiration from paintings created more than 1000 years ago. This series is also another of Li Huayi's ongoing explorations: how darkly and intensely can he apply ink before the painting is no longer viable? In this case the roles of black and white are very nearly reversed with the subject - the rock and bamboo in light while the background is in dark, wet ink. The forms are in light, everything else in shades of very dark ink.

The issues in both these series are complex: past and present, international contemporary and personal, technical mastery, image, style, tradition and even identity.

Conclusion: An era of global economic exchange and awareness does not necessarily equate to a period of global cultural sameness. In such an environment, the innate need for individual and cultural identity can in fact intensify. There are those who become members of a global culture; others find their inspiration, their artistic and personal identity, in exploring their own unique cultural heritage. Li Huayi has found his own voice in ink landscape. His landscapes are all the more personal and Chinese due to his awareness of Western art philosophy and principles. He has the ability to paint in any form he desires; he has made a conscious decision, a choice to make contemporary statements in a very ancient and very Chinese art form. While his voice is unique, he is not the only contemporary Chinese artist to find his or her voice in traditional Chinese arts. This is one explanation for the resurgence of ink painting. This is supported by a growing and maturing audience, both in the West and in China: in China, by those increasingly aware of and proud of their cultural heritage, in the West, by those who admire Chinese art and the artistic accomplishments of an artist like Li Huayi, no matter what their heritage. Li Huayi perhaps puts it best: 'If you want to create something, you base it on yourself, your own situation, your own cultural background, your own tradition. Art can be traditional and still be contemporary.'[8]

Notes

[1] For example, see *The Monumental Landscapes of Li Huayi* (San Francisco, the Asian Art Museum, 2004), plate 2.

[2] *The Monumental Landscapes of Li Huayi*, p. 53.

[3] Ibid, p. 54.

[4] Personal conversation, June, 2014.

[5] ibid.

[6] For examples, see *The Monumental Landscapes of Li Huayi*, plates 32 - 34

[7] Personal conversation, June 2014.

[8] *The Monumental Landscapes of Li Huayi*, p. 54.

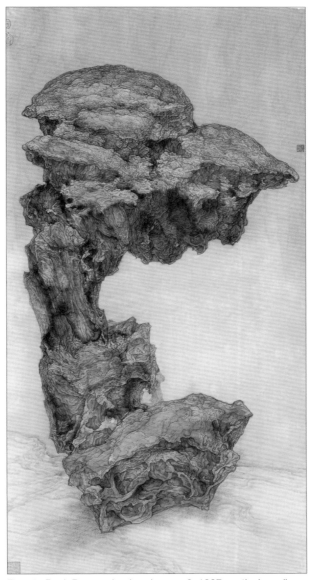

Fig. 10 *Rock Returned to Landscape: 2*, 1997, vertical scroll, ink and color on paper, 155.6cm x 79.4cm.

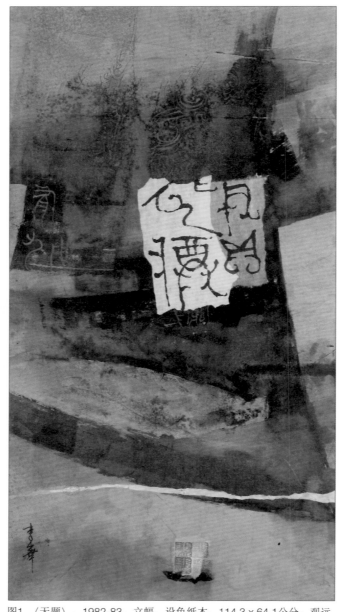

图1 〈无题〉，1982-83，立幅，设色纸本，114.3 x 64.1公分，观远
山庄收藏

传统与创新:李华弌绘画的新发展
倪明昆 博士

1982年当他首次来到美国,李华弌时年34岁,并在中国以艺术家的身分维生已有一段时间。早已成年的他,面对的是一个与他之前经历全然不同的艺术环境,且其生活背景和艺术训练,能提供的帮助亦是有限。那时候的中国刚从文革中出来,根本就没有私人艺术市场,而是由政府长久以来充当这个角色。所以此时艺术家的画艺生活,训练和实践都是在政府机构内进行,并从中获取津贴;其中有些人被要求从事教职,他们的作品根本无需贩售,而且他们艺术的公众认同乃属次要,只要符合机关单位的要求即可。相对来说,在美国地区李氏所面临的艺术环境,批评赞誉和市场导向则是扮演着关键的角色。当他刚抵达时,李氏并无渠道进入这个已建立的行业圈中,而且就他的艺术来说,亦无清楚的市场定位;所以他刚开始是以替主流连锁旅馆提供送货维持生活。这个相似的状况,几乎都是每位艺术家在成名之前,都曾有过的谋生遭遇。

在旧金山的初期,李华弌创作的绘画作品,仍旧持续着他在离开中国之前所发展起来的风格。基于他对中国传统的兴趣,这批画作的风格内容,或多或少都受到从敦煌洞窟中出土文物的启发。[1] 数年之后再回首,他甚至对这批作品感到些许的羞怯;因为它们充满装饰性质、色彩丰富,尤其对他来说,相当容易绘制。之后他被在加州旧金山经营艺廊的罗伯塔·英格利什所发掘,并于1982年时,以他这批敦煌风格画作为主而举行过一次展览。此展在商业上的佳绩,让他日后能以艺术家之姿维持生活,并且成为全职从业者。一如常见的情况,营利上的成功让他去追寻画艺,并使他从其他外务琐事的重担中解放出来。这亦让他开始去探询艺术性的议题。

但在他的获利成功之中,李华弌也面临一个明确的危机。那种停留于商业上可行的绘画又无需拓展艺术边界的诱惑是如此地动人;归根结蒂,如果要在绘制市场取向的作品和替旅馆运送杂货之间作出决定的话,那创作艺术一定是当然选择,尽管这并非全然是个令人满意或是极具挑战的选项。就此情况看来,市场性与艺术家是相违背的;例如一位潜在的赞助人,可能会想要一件他/她已所熟悉的李华弌作品,而对某些全新之作断然拒绝。李华弌就曾面临过这种挑战,在商业化成功和持续拓展艺术界限这两者之间进退两难,然而最终他还是为其自我和生涯,创造出新的艺术挑战。

其实他原本可持续利用这种风潮再创作几年,但他很清楚地认知到这并不能够满足他,而想要继续探索其他的选择。于是,满怀艺术热诚和好奇心态的他,加上之前画作获利成功所得的资金援助,李华弌便选择就读旧金山艺术学院。在那里,他发现到自己正面临着某种分歧,也就是出现在他对美国二次战后绘画理论与实践的迷恋、艺术学院里所教导的后现代主义理论和方法,以及他出身于中国的背景和训练之间。虽然战后的美国艺术,无论在知识上或是视觉上

都引起李氏的注意,但在文革期间,对于练习绘制西方艺术一事来说,他已产生负面观感,所以觉得这些风格的实际创作手法一点也不吸引着他。此外,他对后现代理论的阅读和在美国生活的经历,亦让他想要成为具有'当代'的愿望更加强烈,且逐渐对此用词的复杂性有所觉知。就成为一位当代艺术家来说,他自己有些想法反映出这种背景:"在我的心中,所谓的具有当代,并非只是顺从潮流或是从事流行的事物。这不是说创作装置艺术,只因为这是最前卫的;或是表演行为艺术,因为它取代装置艺术的位置而成为最时髦的。其实'当代'这个词是极为个人的,是属于你自身的感觉,但又与你所处的时空环境而相互关联。"[2]

当不少他的同辈持续探索其他的媒材,多数都是基于西方传统时,李华弌却是属于探寻水墨创作的先锋人士,这乃是最传统的中国媒材。他首先致力于寻找中国艺术传统与西方理论和实践两者间的关联,这在他还是艺术学院的学生时,就已经开始从事,其中包括他使用水墨以抽象形式来进行实验,有时还结合绘画和拼贴手法。他的训练和兴趣促使他专注于抽象纹饰,并自然地应用水墨绘制于作品背景当中,而这些图案都可在传统的陶瓷或是其他装饰艺术的边缘上被发现到 (图1)。时至今日,他都还持续在其绘画当中使用此款技法。

除了阅读西方艺术理论和对战后西方艺术发展如抽象表现主义产生兴趣之外,对于这种绘画风格,其实还有几个其他的灵感来源。根据记载指出,李华弌一直都受到张大千 (1899-1983) 作品的启迪,其正是以泼墨山水闻名于世 (图2)。关于张氏,李华弌曾说:"当我见到张大千的绘画时,我想着:这是一位20世纪的人物,画艺表现是如此典型的中国;但其作品却也属于一种深具国际水平的新式绘画。因此,我想要观者在欣赏我 '21世纪' 的画作时,亦能够感受到同样的氛围。"[3]

拼贴,尽管是一种当代西方的创作技法,但在中国的例子却可在'八破'图中见到,此种技法在19世纪晚期至20世纪初期的上海和其他城市中所使用,这对李华弌来说也颇为熟悉。许多他的抽象表现图式,都是基于中国装饰艺术上的边缘图纹。这些作品虽不像他持续创作的敦煌风格绘画般热卖,但却让他广受好评,并使他在帕萨迪纳的亚太博物馆内有着首档的个人展秀。这个展览是由大卫·卡明斯基所策划,以结合展出他的敦煌风格绘画和抽象作品为号召。其中他的抽象绘画特别受到中国绘画顶尖学者迈可·苏立文的注意,并视他为一位杰出新秀。但清楚可见,李华弌至此尚未找到他独特的艺术表现,所以还在练习这两种极为不同的风格。一种是人物形象,其基于古代中国佛教的传统,且获利颇丰极为成功;另一种则是结合水墨、抽象和拼贴等技法,明显地受到西方概念的影响和获得声誉反应。在往后的近十年间,他持续探索这些风格的不同样式。

至1992年时，李华式到达一个艺术创作交叉口。此时的他已受到传统中国绘画的优秀训练，对于笔墨技法的运用可说是如火纯青。他也发展出一套以商业性为主，并得自于敦煌古代佛教绘画的风格。就西方艺术理论和原理来说，他亦知晓熟识还专精于许多西方创作技法，例如拼贴和油画等。但是，基于许多因素，他选择拒绝这些绘画类型来作为他最后的艺术宣言。首先，他拒绝其奠基于敦煌绘画的风格，尽管此类作品受到市场欢迎，但却缺乏艺术挑战和意义。其次，由于在文革中的自身经验，他拒绝全然的西方创作技法，但却在某些独特的中国作品中，期冀去发现他的自我表现。他财务上的充裕和后现代主义理论的训练，都让他拥有自由去寻找他自身独特的艺术表达。

诚如记载所述，李氏从北宋（960-1279）的巨碑山水作品中获得灵感，进而发展出另一种绘画风格。这可能是因为他的心境逐渐成熟，并且有信心作为一位艺术家所致。也有可能是因为观众与市场对于中国艺术传统的广博和认识，亦有所成长的关系（图3）。在选择创作山水画一举上，李氏与许多当代中国艺术家的潮流逆道而行，是从抽象表现走向具象山水，而非相反的过程。对于这个变化举动，初始他曾受到不少同僚的批评，而且批评家亦云这是不可能成为具有'当代'的，尤其他采用的创作风格是受到超过千年之前绘画的启发。然而对李氏而言，这是他有意为之，无论是从后现代理论来说，亦或是某些事实─因为他发现此种画风和时代与他有着个人和艺术的联系。对于此时期的文献著作，他也阅读研习极为精通。最终作为一种李氏自我的艺术表现，这些作品都相当成功，无论在评论界或是市场上都是如此。日后他还在主流机构举办个展，也曾入选几个当代水墨展览等等。

北宋山水画在规模和概念上有着宏伟表现的倾向，其重视细部且描绘费时；此类画作向来被视为是中国山水画创作的巅峰，以致现存的少数作品都被公认为国宝。当他还年轻时，李华式就为其所震摄。但是，自宋代结束后，并没有太多的艺术家有着耐性来从事此项画技，或是能捕捉到其本质精微所在。然而，张大千却是这些艺术家中的特例，尽管他偶尔为之，又经常采用临摹仿造的形式呈现。

绘制过程的重要性，对于李华式个人和吾人看待他的作品来说，是不能够被轻忽的。在当代艺术理论和创作实践中，绝大部分都是属于概念性质，因此艺术家技艺的直接显存就不被视为是主要关键。但李华式在其作品的形式和风格上，都选择从事一种需要高度技巧的繁复工作。他喜爱创作时的过程，并认知说到他从日常生活的担忧和挑战中，藉此来寻求慰藉。然而艺术史家或是艺评家大多充斥着哲思辩论和分析，却极少关注当他开始作画时是如何动笔；其实对他来说，这些讨论的重要性，只存在于创作时的概念阶段，也就是当他开始实际绘画时，它们只会被抛诸脑后，然后他便沉湎自我埋首创作之中。

李氏在一年里并没有创作出很多作品，就他而言最大的挑战，乃是绘画接近完成时的感觉。什么才算是足够？什么时候才是适当的时机去结束这描绘的愉悦活动，而称这件作品已经完成？无论如何，他总

是知道极限所在而在何时停止。他曾明确指出在每件作品中，对他来说当清楚到达某点时，就算是大功告成，此时若再增添一笔的话，就会嫌多。他说到："我一次画一笔，最大的问题之一就是要正确组合这些线条。如果画面中有条笔线并不好，都将会毁掉那个部分，然后是整幅作品。"他认为拙劣的笔法就是线条不够雅致，或是于形式构图内和抽象感觉上，其运行至错误的方位，而非正确的走向。此外，所谓优秀的线条则创发于精良的笔触，但如下笔错误也是枉然。每个地方都需要正确的技法。由此看来他的绘画作品，正反映着其人格特质，是力求典雅而非妍丽；他坚持他的笔法必须在形式和构图上正确无误，而非讲求装饰外观。诚如他所言，一个技艺熟练的笔法，如果是超出所需的话，也是丑陋不堪的。

当他持续进行山水绘法的研究时，李华式自身却遭遇一些艺术问题和挑战。他说到从构思当中去采用一个新概念，然后到付诸实行完成作品，这是一个深思熟虑的过程需要时间。他需要一个准备阶段，如果他仓促赶工的话，就无法成功。"若想要一气呵成的话，你之前必须要准备知道什么是可行的，什么时后是走向正途。"[4] 经由数个系列的作品，他越来越倾向于探索他的主题，而非仅是单独的山水画作。在每个系列当中，他都在寻找"某种我之前未曾做过的事情，某种在水墨绘画习规中崭新的部分。"[5] 他用谨慎熟虑的式样来应付这些挑战，甚至花费长达两或三年的时间以建构概念，并在心理和艺术上做好准备。这些结果可从其一系列相关的绘画中所看见，此类作品都是他致力于某个特殊挑战的探究。在这个展览中将呈现两个系列作品，其讨论如下。

1997年纽约怀古堂曾为这批山水画举办一场成功的展览，让他的努力得到回报并受到鼓励。这些作品都颇受好评，市场反应甚佳。如此的热烈回响给了他信心以持续探索他的新视野，自此之后他便一直采用此类的创作形式。这些山水作品清楚地显示他的抽象画踪迹，但却更加强调笔触。其中大幅的创作形式乃是以笔墨渲染的手法而成，一如他早期的抽象作品，但在细部上更是以精微笔法煞费苦心层层堆叠。这类枯劲的山水画作中并无人物存在，反映出艺术家的艺术兴趣和他对于自然环境的关注。

2004年亚洲艺术博物馆曾举办《李华式巨碑山水》绘画特展，所获佳评如潮。到那个时候为止，李氏创作山水画的时间已超过十余年，他的技法亦开始'精凝化'。与此特展同时出版的图录，就是艺术家和笔者之间，一段历时长久又富乐趣的会谈成果，共积累17个小时的录音纪录。这些讨论清楚地说明李氏关于当代艺术理论的熟识，并且对其绘画造成影响。

虽然获得评论赞誉和市场成功，但危机又再度出现，也就是李华式有可能习于常规，而不再能够持续从事创新或是推进他的艺术形式。尽管这从非易事，但他还是给自己订立下特别的艺术挑战或是议题，并且通过创作系列绘画，来为这些问题寻求解决之道。过去他曾探索过不少议题，像技法和抽象等。且这些议题的创作实践，亦有越来越多的中国特征。举例来说，他于2003年所从事的创作里，就有一个系列被他称为'暗沉绘画'（图4）。对于这批作品，他说到："

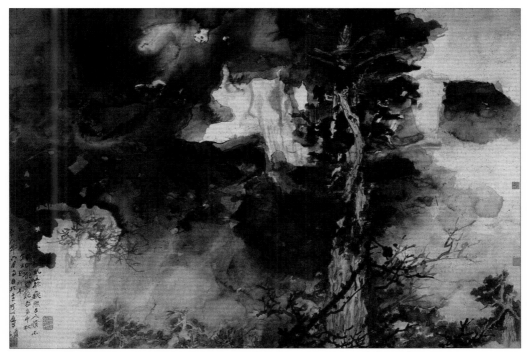

图2 〈台湾神木〉，张大千(1899-1983)，1970，设色纸本，151.4 x 211.8公分，旧金山
亚洲艺术博物馆，B73D4

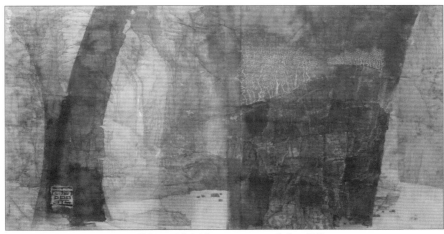

图3 〈灵景皓木〉，1993，横幅，设色纸本，66 x 124.5公分，怡情
斋收藏

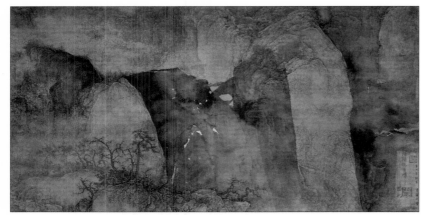

图4 〈山水〉，2003，横幅，设色纸本，67.9 x 128.3公分

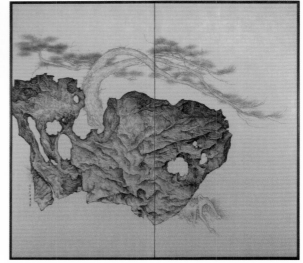

图5〈峋石劲松〉，2008，双幅屏风，水墨绢本金箔地，185 x 170 公分

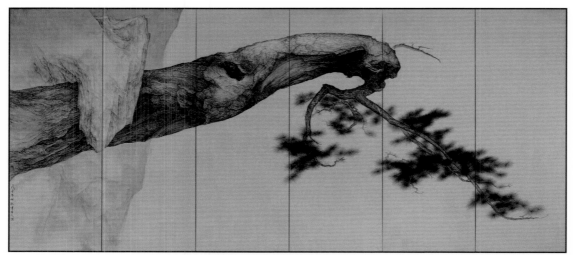

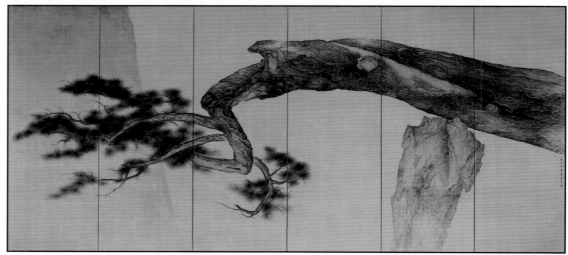

图6 〈恣意纵横〉，2008，六幅屏风一对，水墨绢本金箔地，每幅 382.0 x 176.0公分

这个暗沉系列颇具挑战：墨色浓厚层叠的运用，是极须技巧性非常困难。虽然我是在描绘山水景观，但我的概念却更为抽象；我想要去探索、去挑战我的画艺能耐，甚至涉足某种艺术冒险，看看在此风格中，可以完成到什么程度。"[6]

如果说暗沉系列是在研究水墨色调和对比的话，在那时他所开始进行另一个系列的作品，就是对绘画基底表面的探究，也就是以金箔为例。虽然对此某些他的灵感是从张大千那里而来，但他仍尝试做些与之相当不同的举动。为了实验之需，他去购买一些未曾着色过的陈旧日本金箔屏风并在上创作，另还有纯粹纸本和绢本材质。刚开始时，他并不满意他的初期练习成果，所以销毁部分作品。但后来他却发现有两个解决之道，就是使用金色丝绢和敷金纸张。此类绘画可见于他在2008年完成的数件巨幅作品（图5和图6）。他陈述其绢本创作说到："虽然我很小心翼翼地敷色，但绘制过程还是相当困难（与纸本比较起来）。水墨并不易渗透到表面里，不像纸张一般，而结果有时会出乎意料之外。不管艺术家是如何小心地设计，但最后成果总是会与之不同。"

除了各类媒材之外，李华式也在形制上从事一系列的实验，在规格的变化上亦是如此。上头所论及的金箔绘画，就是其巨幅创作的例子。在这他采用的方法是聚焦于大胆简约的形式，并强调轮廓外型。画面的大部份都予以留白，在描绘范围和素底区域之间建构出突显张力。在描绘的细部中，则使用精微的笔触，让这些作品从远观到近看，都存在着视觉趣味。

另外他也完成一系列的小型绘画，特别专注于团扇形式，其经常可见于北宋绘画的作品中。因为这些扇面绘画小巧，与那种屏风巨型大胆的形式并不适合，所以此类作品都以极为精工的笔触绵密绘制（图7和图8）。这些扇画都有着不同的外型，例如圆形、椭圆形和不规则四边形，都代表不同构图的创作挑战。其他在绘画内容上也颇为相异，像在小巧作品中，常有建筑物形或甚至出现人物等叙事元素，而大幅作品则是以表现山水或是巨型树木为主。他还曾创作一系列的扇面作品，以赞扬中国的十二生肖，这与他的巨幅山水创作截然不同。最后，还有一个他曾讨论过的传统构图形制，但尚未进行处理的就是手卷。

尽管他的画作形制是属于传统中国式，但李华式仍力图变化一如其作〈山岳潜龙〉（图9）。在这他探索屏风形制，却也表现出某种新式和不同的地方。其中有六幅屏风是以大幅墨色渲染描绘，并成为另一件挂轴之后的背景帷幕，而此画正是李氏的工笔山水作品之一。整组构图连续，可说是件独特又具震撼的作品。虽然以此技法完成的传统作品并无范例流传下来，但他却为这种结合方式找到文献参考资料。对中国山水绘画传统构图中的'主/客'山体而言，这可说是个全新诠释。在这里中幅挂轴是宗主，而背景的山脉便成为配峰。

挂轴一直是李氏作品中最常见的形制。他尤其偏好巨幅创作，并说："规格可以是具有当代性的，焕然一新，有点新潮又有不同。"此外，他现在的绘画工作环境，也与十年之前的情况大不相同。如同他在1980年代移居美国的同辈中人，李华式现在主要也

是待在中国，并且大部分的画作都是在他北京的画室内完成。在中国，当代中国水墨绘画的市场正逐渐升起，且李氏的主要赞助者则散布于台湾、香港和内地以及美国与欧洲等地。这些中国买家日益成熟，对于传统的作品形制和基于传统的当代绘画主题，都不再迟疑观望。

如上所述，此次展览共推出两个新系列的绘画作品：一是月下竹石，另一则是新创山水。在这两者中，李华式都从之前的画作内吸收经验，并在他曾探索过主要的抽象技法议题上加以突破。

他描述这系列的山水作品是针对'柔软'的研究，但与其对比的'坚实'他也同时在进行创作。这些复杂形而上的用词，其实与'阴/阳'的概念相互关连，是中国哲学的基石。因此，他正从中加以拓展，采用非常中国化、极为传统但又全然一新的方法。

李华式曾创作出一批绘画，外观看似'柔软'。然而，就技法来说：他称之为'皴纹皴法'，并以此笔法建构出山体形式。这些风景笼罩在一片岚雾之中，有着少量水气。最近这个系列的画作是对哲学和水之物质软性的研究。他同时的作品亦是对岩石'坚实'的探索，企图"在岩石中去捕捉世界，获取宇宙"[7]。在此类'坚实'的画作里，全无柔软的感觉，这里没有树木且水份的存在感也减至最低。整个形式是以强力的笔触所完成，经常使用短小有力的笔法去绘制轮廓。画面景观形式非常精致分明，看起来颇具份量，且轮廓锋锐相当易脆。这些景物透露出一种结晶体般的模样，完全没有他早期作品中常出现的柔软岚雾。

相对来说，在此展中的绘画都是关于水气和柔软岚雾，且全是挂轴形制。在第一类作品中有幅垂直挂轴，其间磅礴的瀑布占据着画面中央。从高处岩壁上直落到中央的凹穴，且周围树丛林立，与因瀑布产生的岚雾相互对应。之后便从一条粗旷的狭道中，分流数支直至前景。这个戏剧化的瀑布场景，是采用深沉几近全黑墨色的山体来描绘强调。而流水的动感，则是由许多不同细长成丝的笔法所表现出来。这无疑是艺术家本人，所创作出水流特性最为惊人的展现。

在此系列中的第二幅画作有着狭长水平的走向，几乎就像是从艺术家某件早期山水画内的细部放大而来。数条窄溪的下端显示着支流进入到中央凹穴之中，其汇聚水流为一，并且瀑布从岩壁临降而流向前景。显眼的零星树丛与背景的岚雾相互呼应。在这里画面背景并非深沉，描绘的水流是以灰墨广阔的笔法表示。流水的动感则反映着其对山石景观的冲击。

组图中的第三幅绘画，也是以水平走向来表现山林景物。但在流水和山林之间的形式区分，却开始逐渐模糊，彷佛山林消溶于瀑布支流中，或是与之融合为一。岩壁部分则是以浅灰墨染，并逐渐向远方发展，直至消失于潮湿柔软的氛围当中。

有三幅绘画的第二类作品，则是代表着艺术家对于岩石的新探索。根据李氏所言，在中国有两款岩石种类，是适合于收藏与展示。第一是所谓的'供石'，其被用来展示于桌案之上或是其他的室内环境之中。第二则是'赏石'，此类岩石经常可在庭园中被

发现到。虽然这两种都有其优雅之处，但'赏石'可说是更具自然元素。

文人玩石的描绘早已成为水墨画家们彼此往来的社交轶事，其多数都是在从事'供石'的绘制，此类石头经常可在文人的桌案上见到。这些绘画经常包含着一块单独的岩石，而无其他脉络，仅有素纸作为背景而已。但是，李氏却创作出一个场景，在夜晚时分时，将石头放至于庭园当中，其旁还有竹子相伴。他结合了'供石'的雅致和其雕塑性质与'赏石'的整体环境。在这个系列里，岩石被呈现于月下的竹林花园中。他有意把'赏石'（园石）的雕塑性和其表面肌理，与'供石'（桌石）的特徵合而为一。在他的心目中，'供石'虽然与沉思多所相关，但也可存在于某种脉络，像室外花园的环境里，而'赏石'亦有其冥想特质。另一不同之处，乃是完成作品的所需时间。李氏说到大约需要花费两天的时间，就可绘制一幅单独的'供石'，但在其系列绘画中，一幅作品就可能要耗时两个礼拜才能完成。从1990年代起，他便开始描绘这些回归自然环境的岩石图像，就像1997年的〈灵石傲世〉画作便是一例（图10）。

在这个系列作品中，他还受到〈雪竹图〉的启迪甚大。此作现藏上海博物馆，传为是五代画家徐熙的作品。此延续着李氏对于后现代潮流的兴趣，以追求超过千年之久的绘画为灵感来源。这个系列也是李华弌现在正在进行的探索：他能运用深沉厚郁的墨色到什么程度，直到画作不能够被辨识为止。就这方面来说，黑与白的配色就与描绘主体几近相反，岩石和竹林是以浅色表示，而背景却是深沉潮湿的墨色。也就是景物形式外观呈现明亮的状态，除此之外，其余的部分皆笼罩于深色墨韵中。

由此来理解，这些系列作品的创作议题都颇为复杂：过去和现在、国际当代和个人处境、技法掌握、想像、风格、传统，甚至是身份认同等。

总而言之，所谓全球化的经济交流和意识崛起的时代，并不一定要与全球文化的同一性画上等号。在这样的环境当中，个人先天的需求和文化认同，其实能予以强化增大。或许有些人成为全球文化中的一份子，但也有些人从探索其自我独特的文化遗产中，去找寻灵感启迪、艺术美学和个人认同。李华弌就是在水墨山水创作中，找到他自我的声音。由于对西方艺术哲学和原理的认识，使得李氏的山水画总是与自身和中国息息相关。他能够从心所欲以任何形式去描绘事物；他自觉地作出决定，此一抉择让他以遥远古代和中国艺术的形式，为个人及其当代作出宣言。尽管他的表达是独特的，但他并非是唯一的当代华人艺术家，在传统中国艺术里去找寻个人表现。这可解释水墨绘画复苏的现象，已受到逐渐增加的成熟观众支持，无论西方或是中国皆是如此。在中国，认识到其文化遗产并感到骄傲的民众开始渐增；在西方，也越来越多人欣赏中国艺术，敬服像李华弌等艺术家的成就，而不论自身传统为何。对此，李华弌也许说得最好："如果你想要从事创作，你必须忠于自我、考虑自处条件、立基于自己的文化背景和以自身传统为起点。由此，艺术就可以是具传统感而又富当代性。"[8]

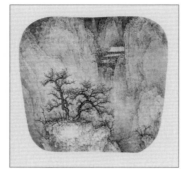

图7 〈寒馆〉，2007，扇形册页，设色纸本，17.0 x 18.0公分，观远山庄收藏

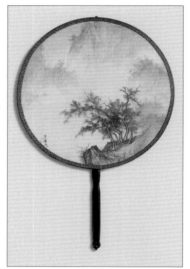

图8 〈雾谷晓树〉，2007，圆形纨扇，设色绢本，直径26公分，观远山庄收藏

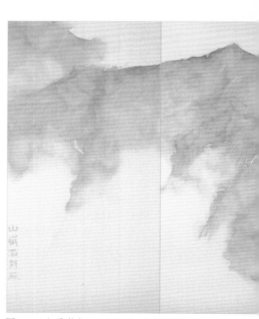

图9 〈山岳潜龙〉，2008，六幅屏风，单幅挂轴居前，设色纸本，每幅 91.5 x 183.0公分；前挂轴 97.0 x 201.5公分

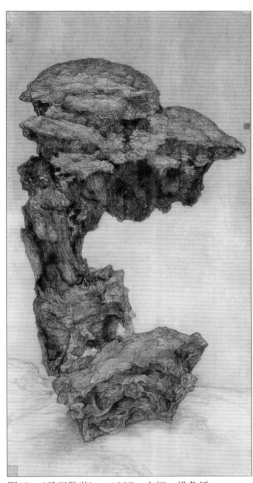

图10 〈灵石傲世〉，1997，立幅，设色纸
本，155.6 x 79.4公分

1 范例可见《李华弌巨碑山水》画展图录（旧金山，亚洲艺术博物
 馆，2004），图版2

2 《李华弌巨碑山水》画展图录，页53

3 同上，页54

4 个人访谈，2014年6月

5 同上

6 范例可见《李华弌巨碑山水》画展图录，图版32 至34

7 个人访谈，2014年6月

8 《李华弌巨碑山水》画展图录，页54

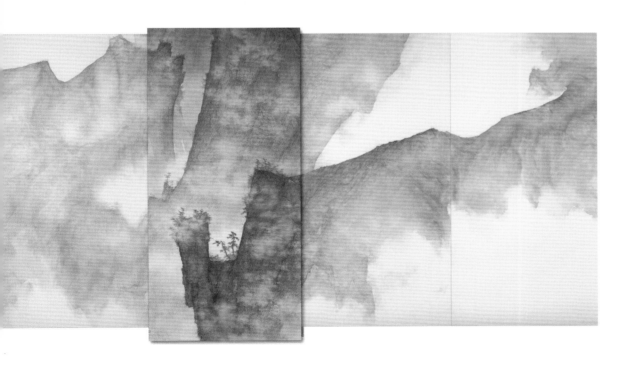

Catalogue

**Waterfalls, rocks and bamboo
by Li Huayi**

1
Pure Echo in the Empty Valley
Ink and colour on paper
Dimensions: 156.0cm by 81.0cm

Signed: Jiawu zhongxia Li Huayi bi,
(Li Huayi painted this in mid-summer of
the Jiawu year [2014])
Artist's seal: Li Huayi yin

空谷清音
纸本設色水墨
落款：甲午仲夏李華弌筆
鈐印一方： 李華弌印

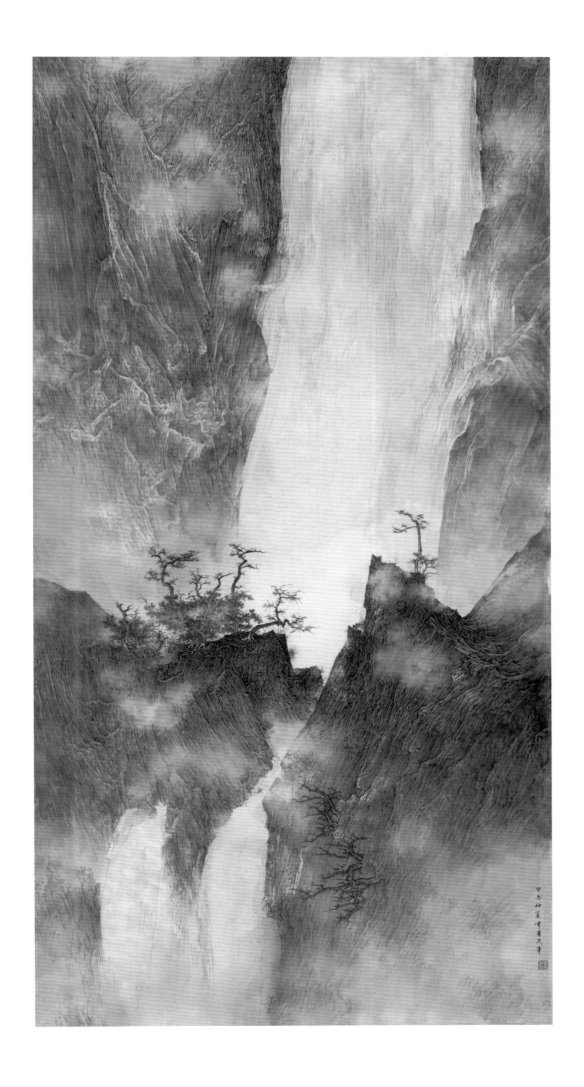

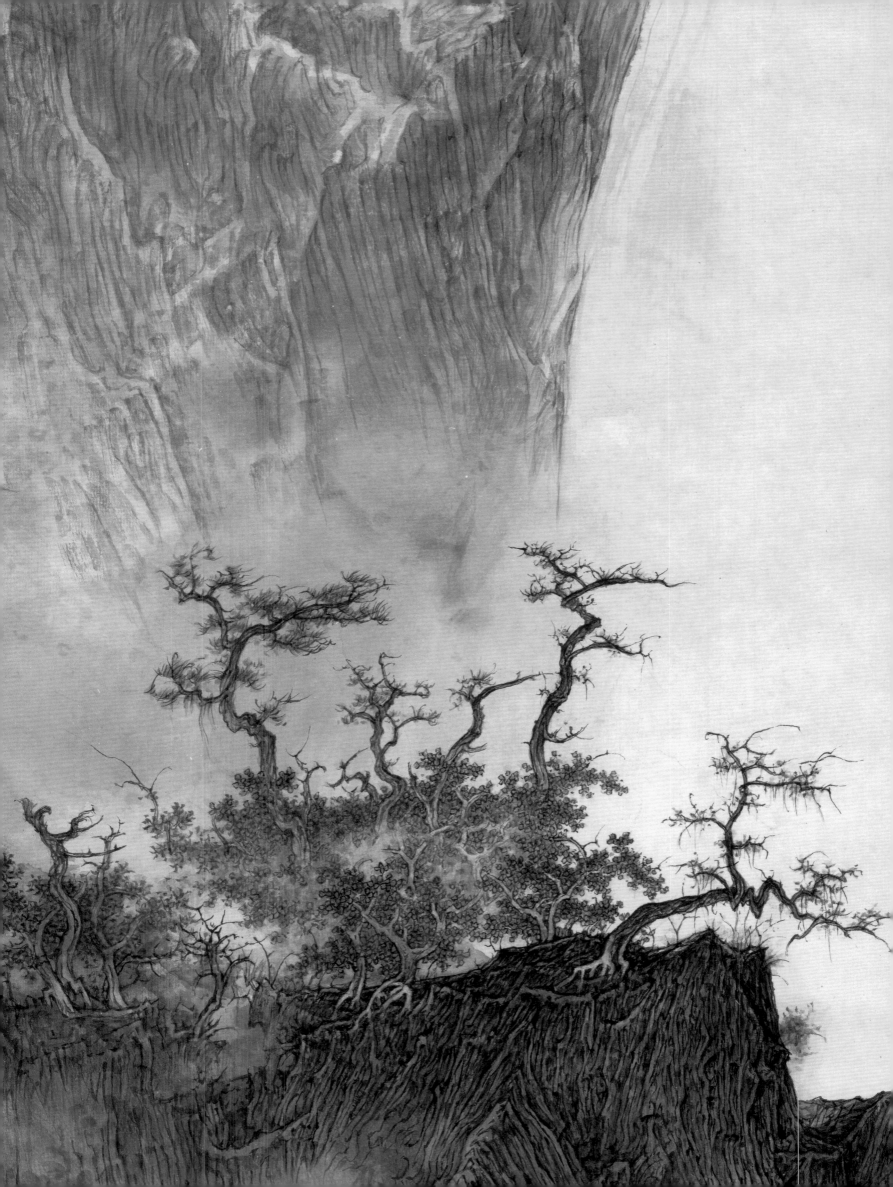

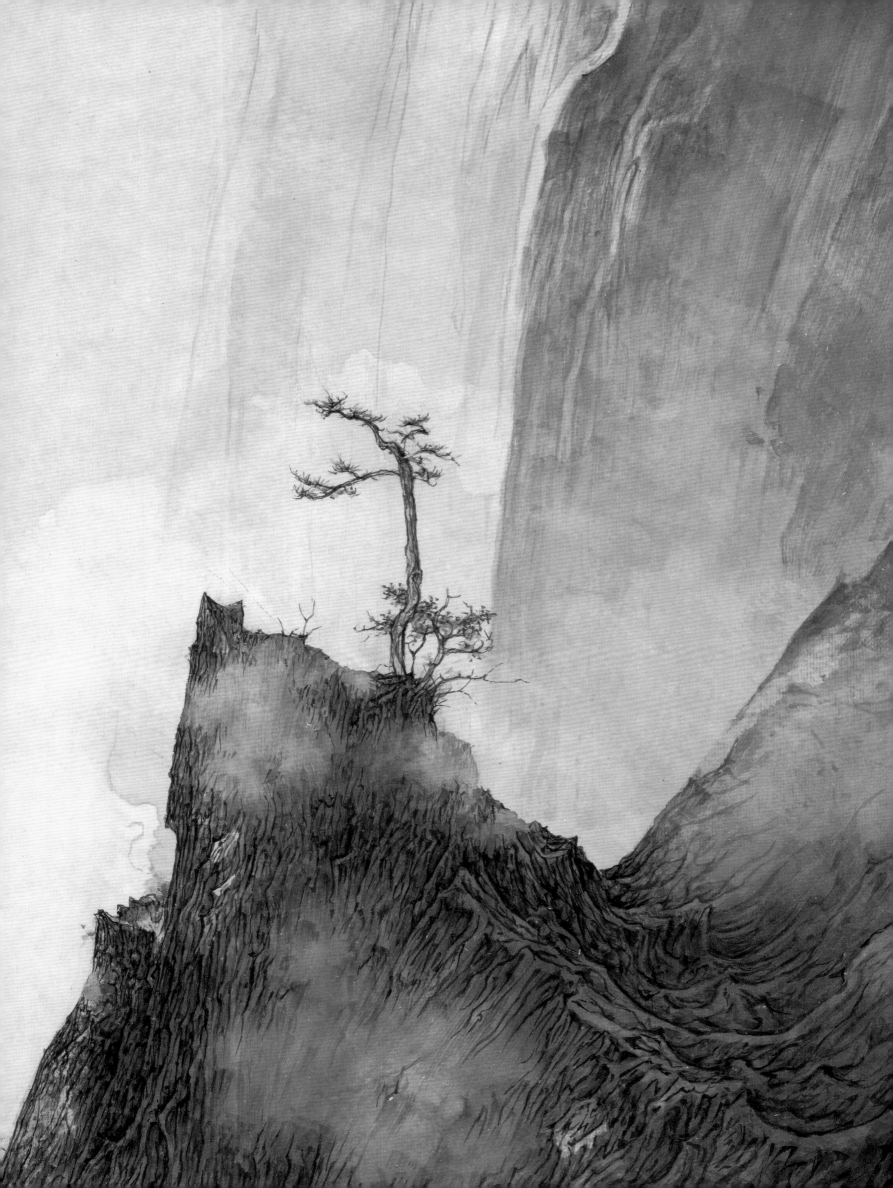

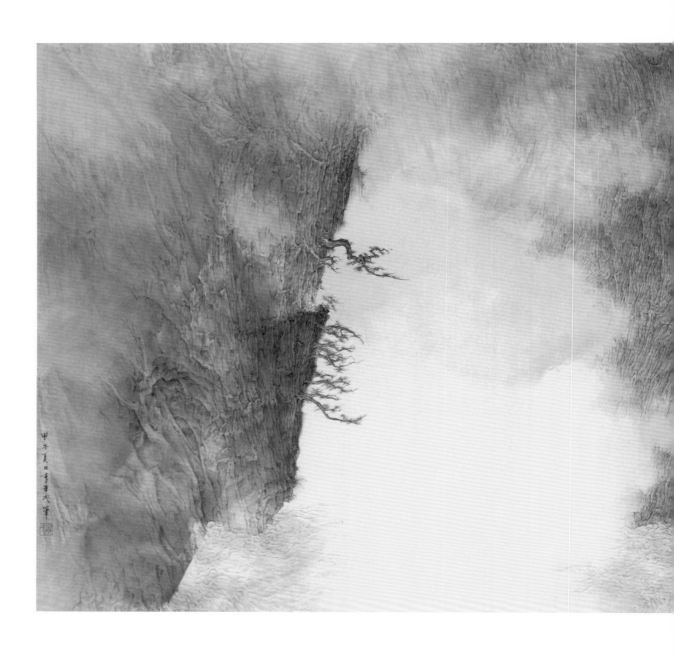

2
Rising Mist
Ink and colour on paper
Dimensions: 79.5cm by 177.0cm

Signed: Jiawu xiari Li Huayi bi,
(Li Huayi painted this in the summer
of the Jiawu year [2014])
Artist's seals: Huayi *(lower left)*
Yihuakaiwuye *(lower right)*
Taolibuyan *(upper right)*

煙岫夢澤
纸本設色水墨
落款：甲午夏日李華弌筆
鈐印三方：
左幅：華弌
右下：一華開五葉
右上：桃李不言

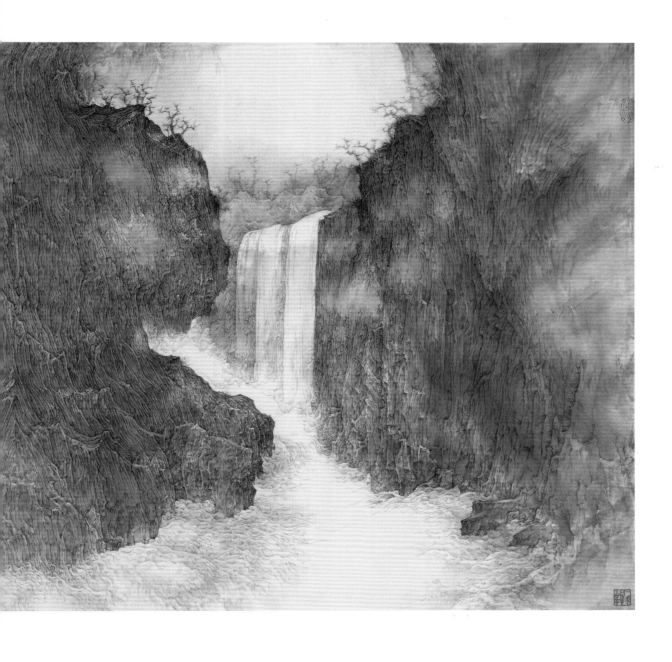

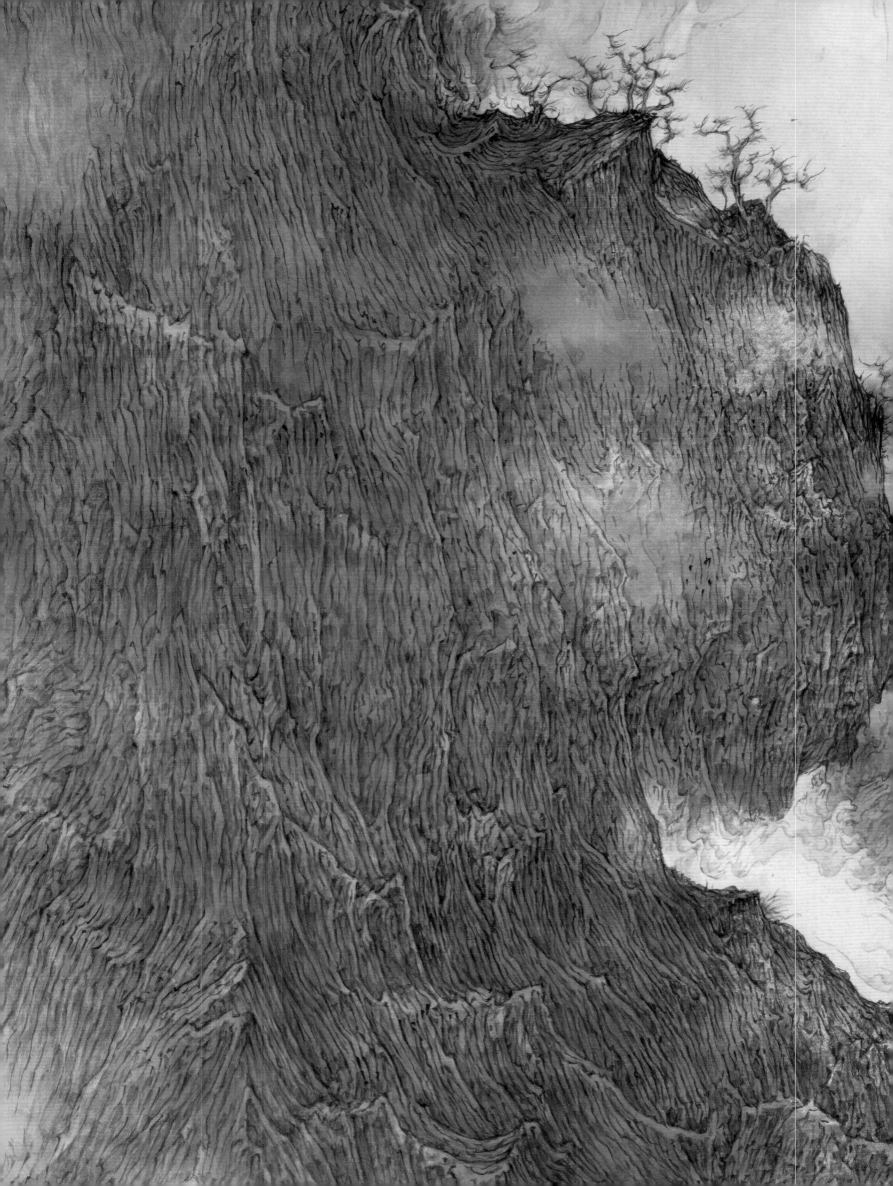

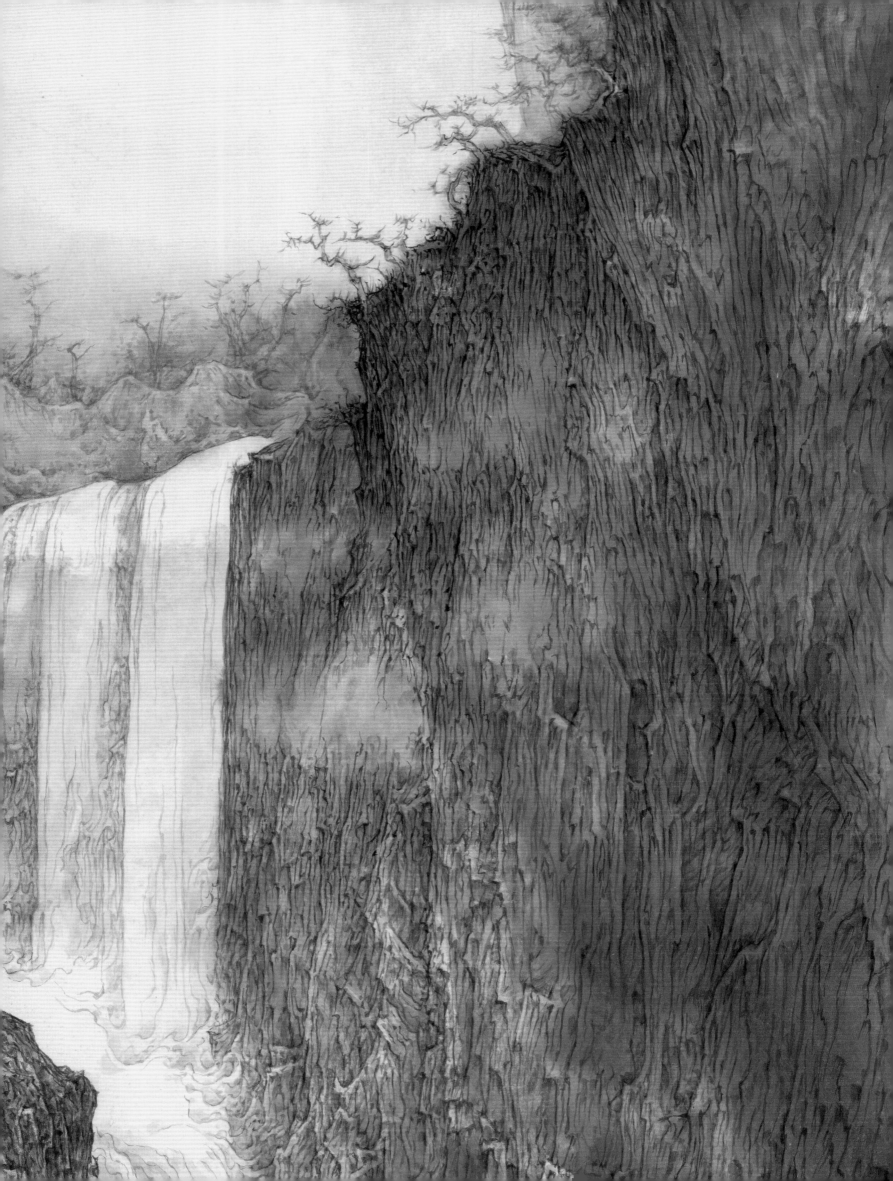

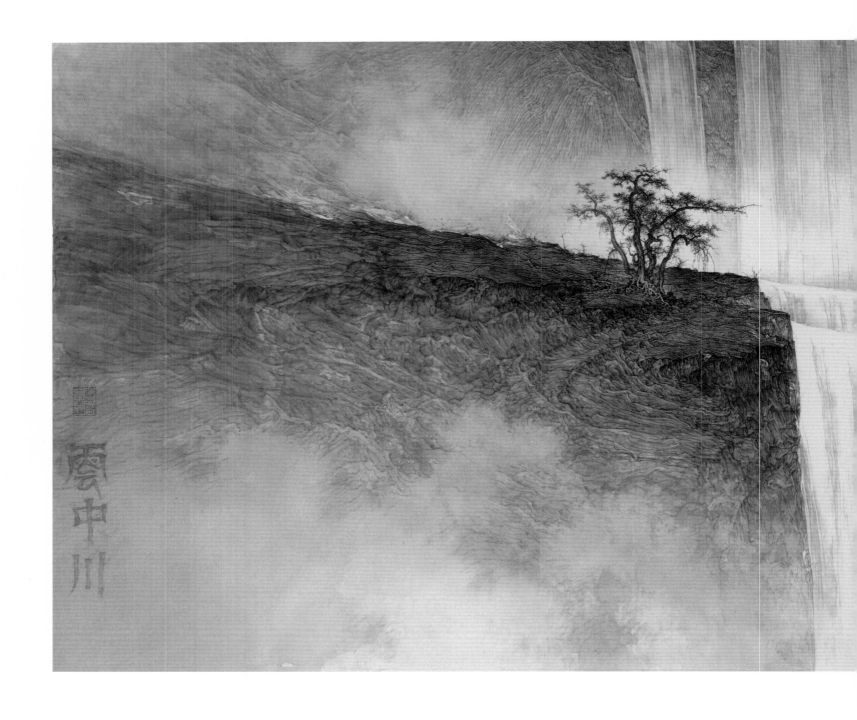

3
Waterfall Amid Clouds
Ink and colour on paper
Dimensions: 88.5cm by 229.0cm

Inscribed: Yunzhongchuan,
(Waterfall Amid Clouds)
Signed: Guisinianmo Li Huayi bi,
(Li Huayi painted this at the end
of the Guisi year [2013])
Artist's seals: Fanjianqiuyishan (left)
Li Huayi yin (lower right)
Daoshengyi (upper right)

雲中川
纸本設色水墨
落款：左幅：雲中川
右幅：癸巳年末李華弌筆
鈐印三方：
左幅：繁簡求弌善
右下：李華弌印
右上：道生一

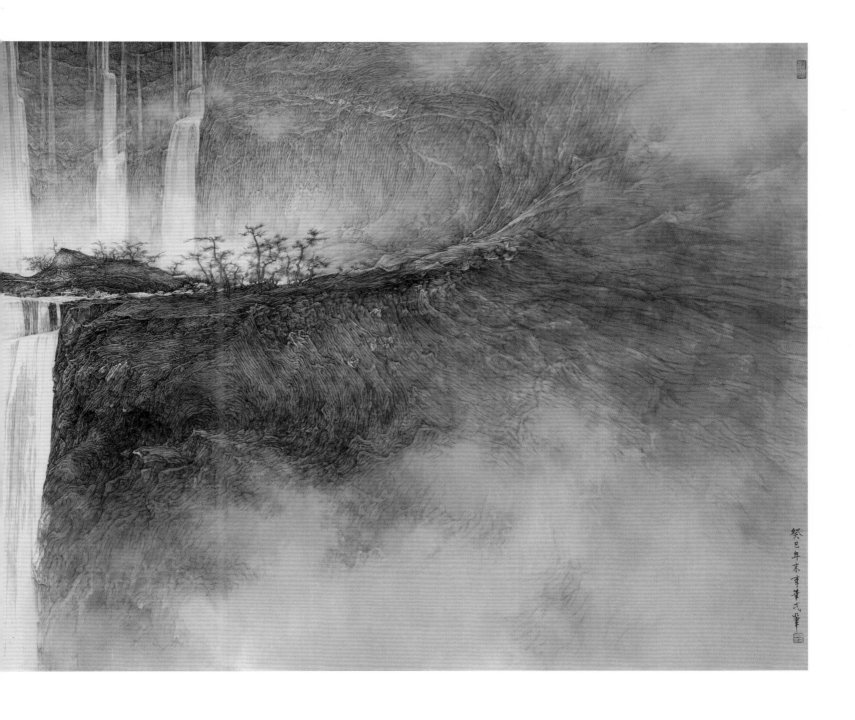

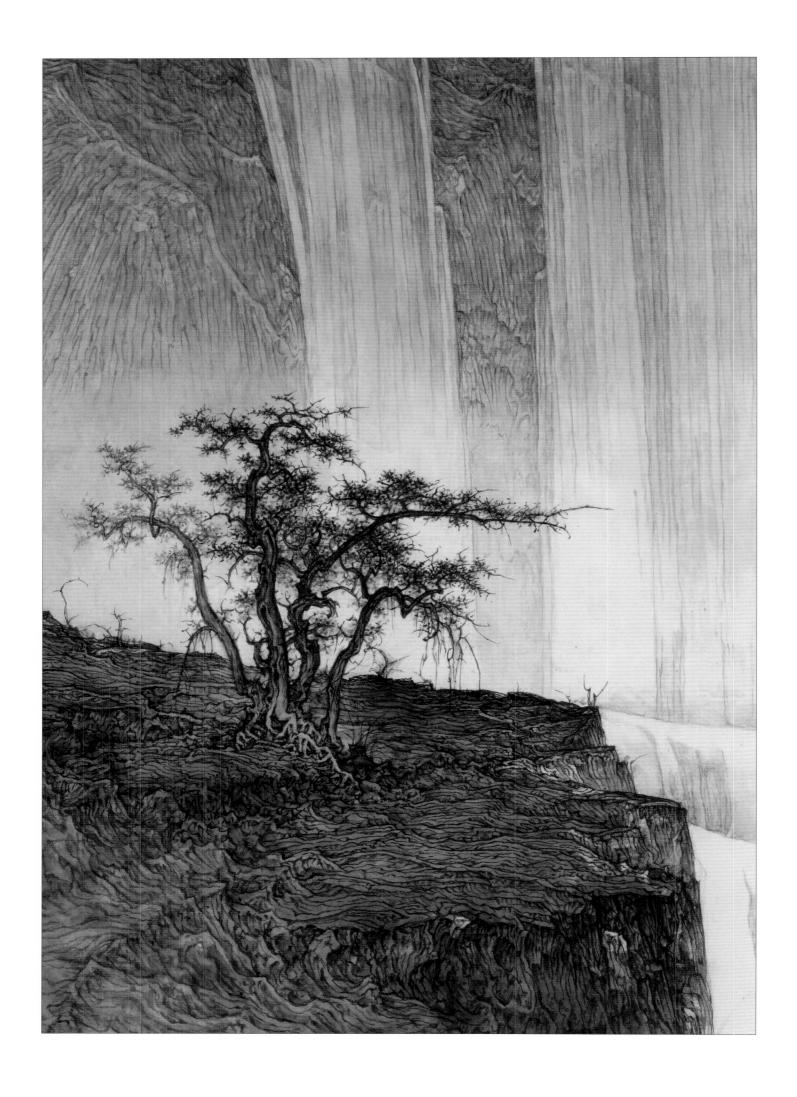

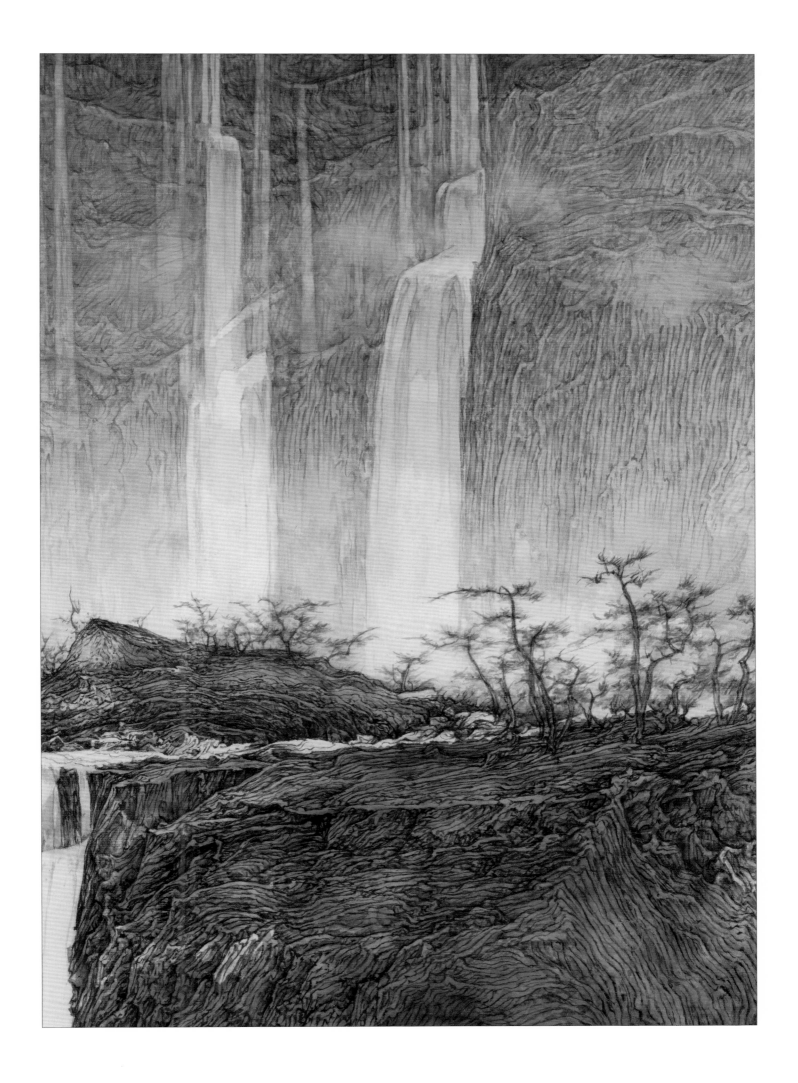

4
Torrent
Ink and colour on silk
Dimensions: 176.0cm by 88.0cm

Signed: Jiawuchunri Li Huayi bi,
(Li Huayi painted this in the spring
of the Jianwu year [2014])
Artist's seals: Huayi *(left)*
Yihuakaiwuye *(right)*

飛流急瀉
絹本設色水墨
落款：甲午春日李華弌筆
鈐印兩方：
左幅：華弌
右幅：一華開五葉

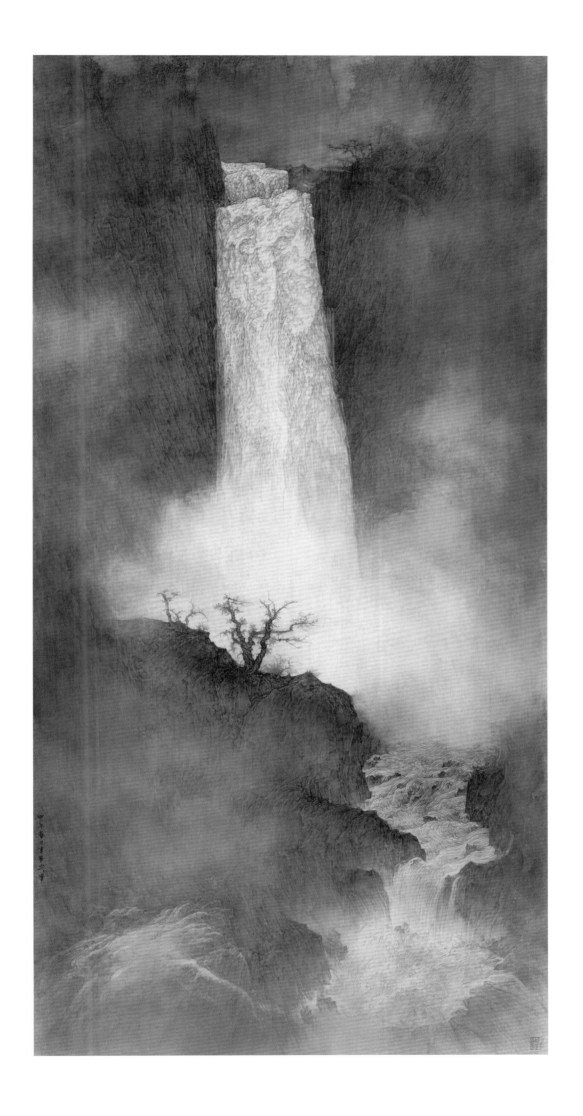

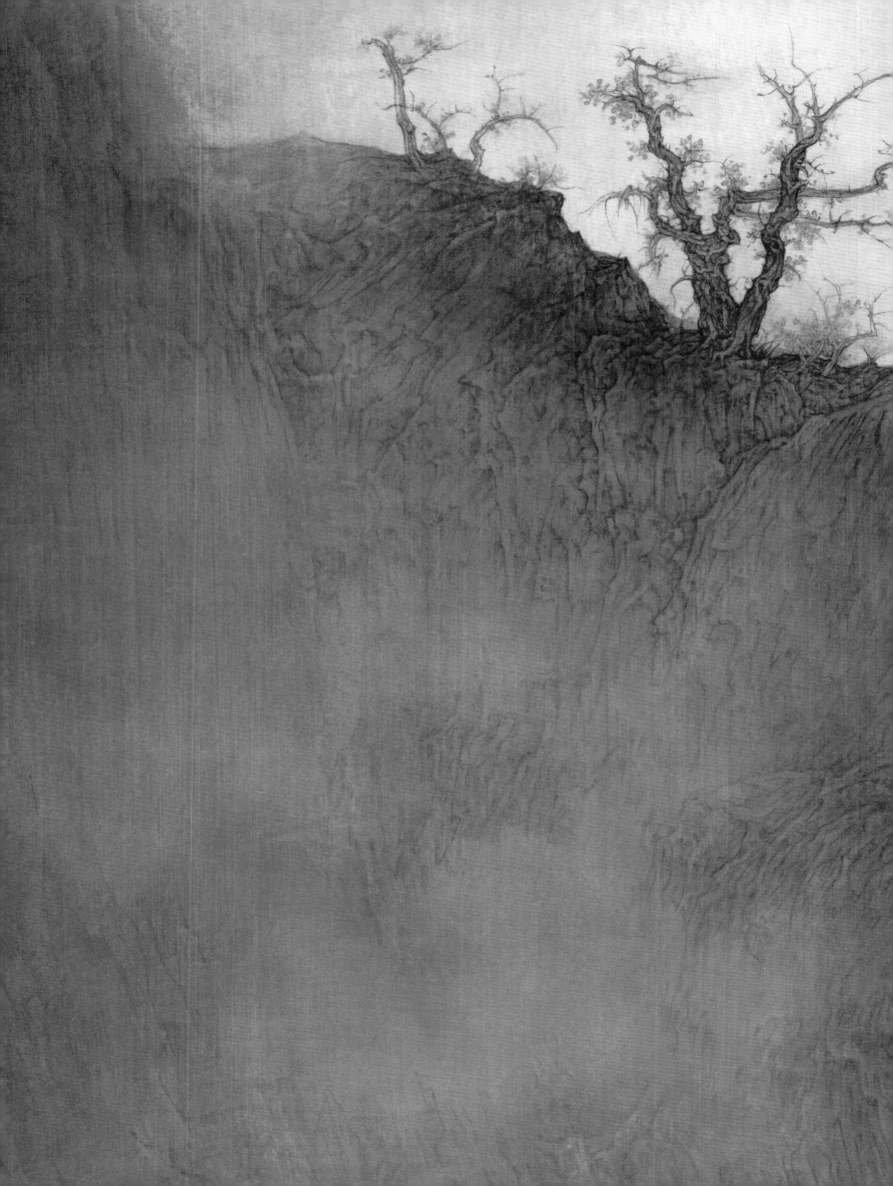

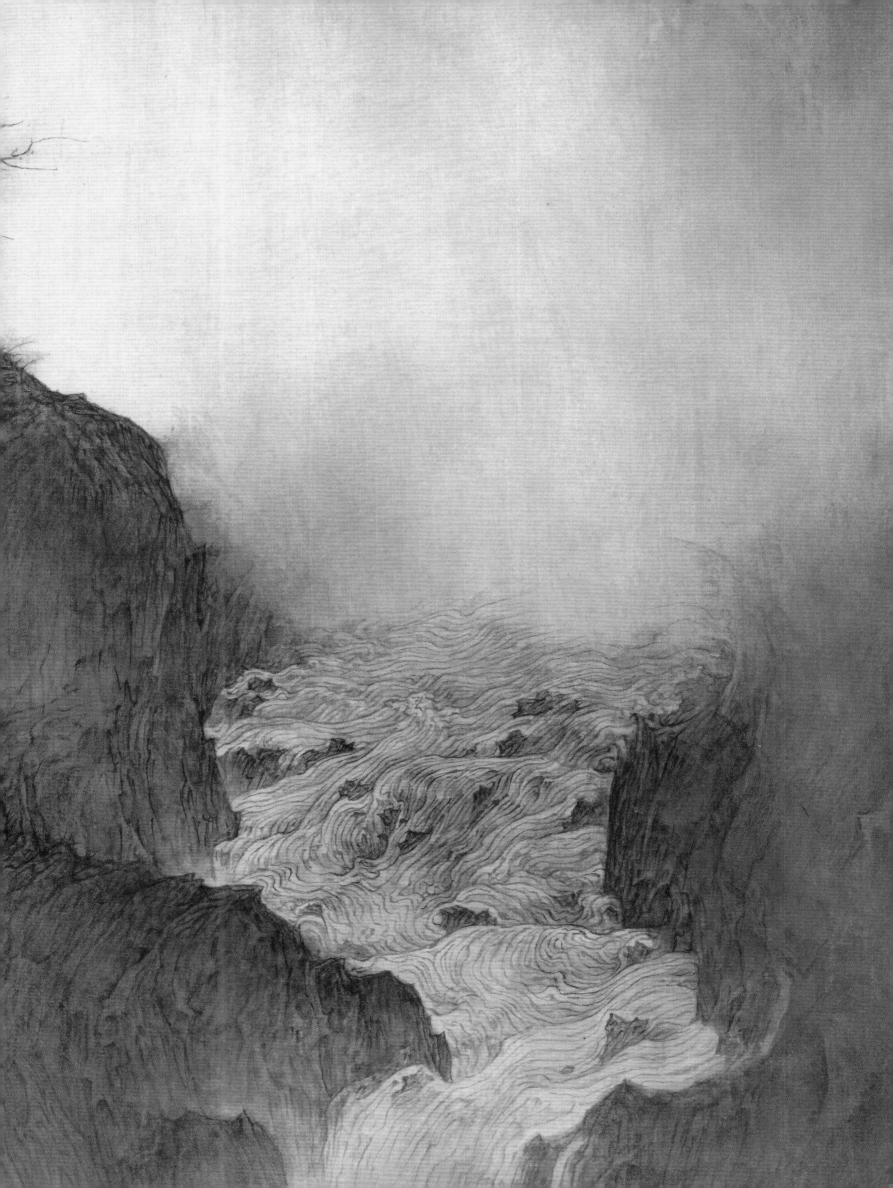

5
Rock in Moonlight I - *Rock, Bamboo and Autumnal Tree*
Ink and colour on silk
Dimensions: 106.8cm by 65.0cm

Signed: Li Huayi
Artist's seals: Shihuaweizhan *(left)*
Li Huayi yin *(right)*

月下石 一　寒石幽篁
絹本設色水墨
落款：李華弌
鈐印兩方：
左幅：始華未展
右幅：李華弌印

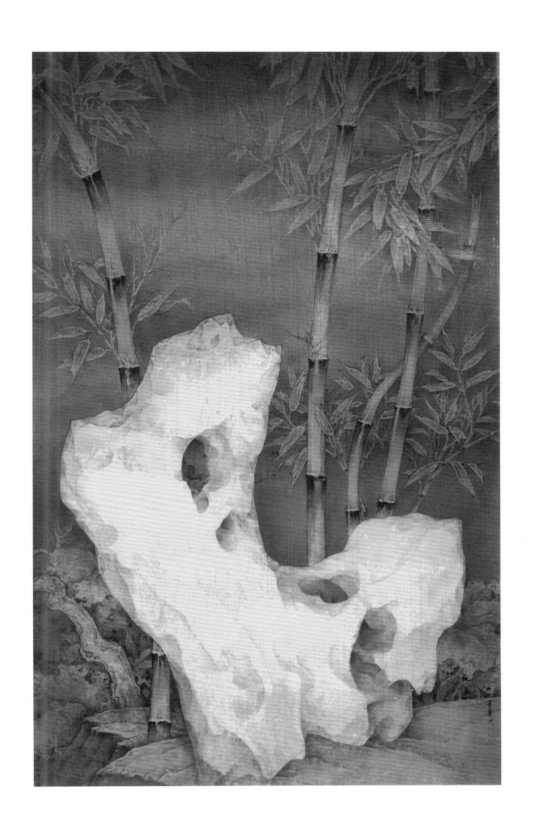

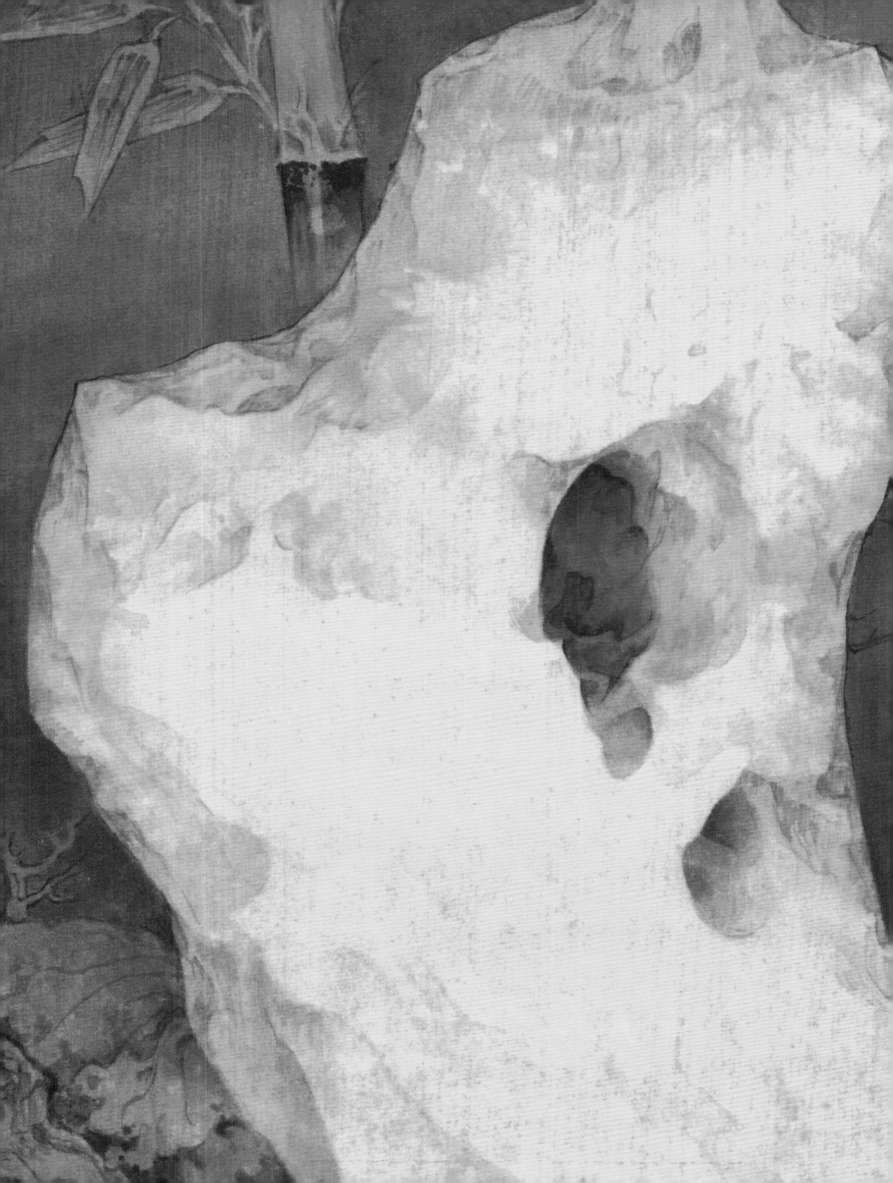

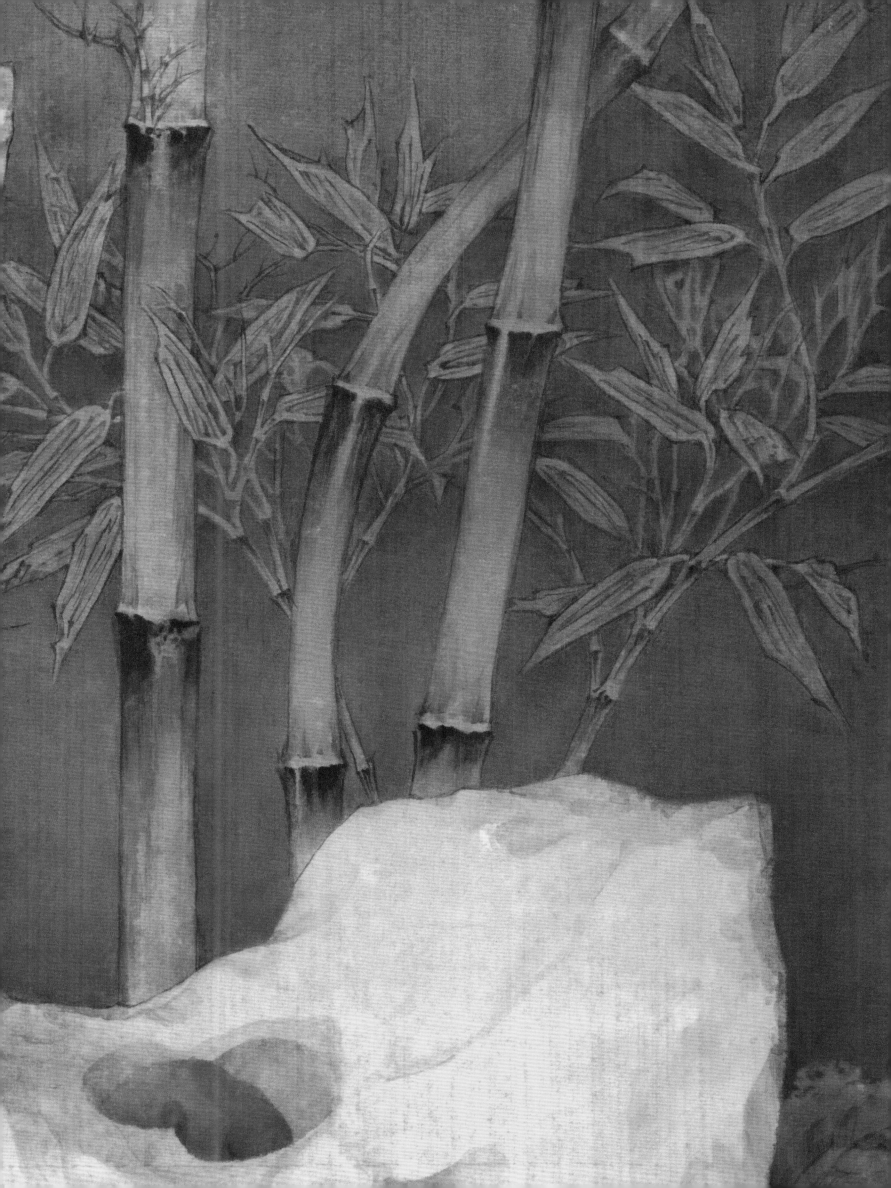

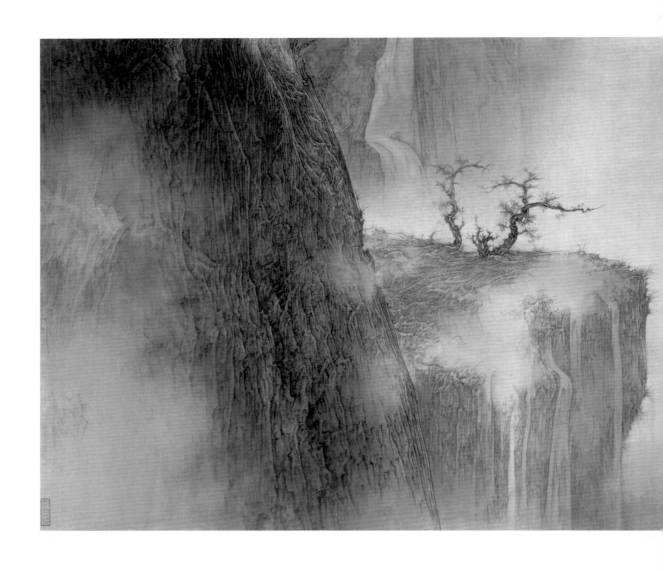

6
Sound of Waterfalls
Ink and colour on silk
Dimensions: 64.0cm by 164.0cm

Signed: Li Huayi
Artist's seals: Duchengyige *(left)*
Li Huayi yin *(right)*

處處落水聲
絹本設色水墨
落款：李華弌
鈐印兩方：
左幅：獨成弌格
右幅：李華弌印

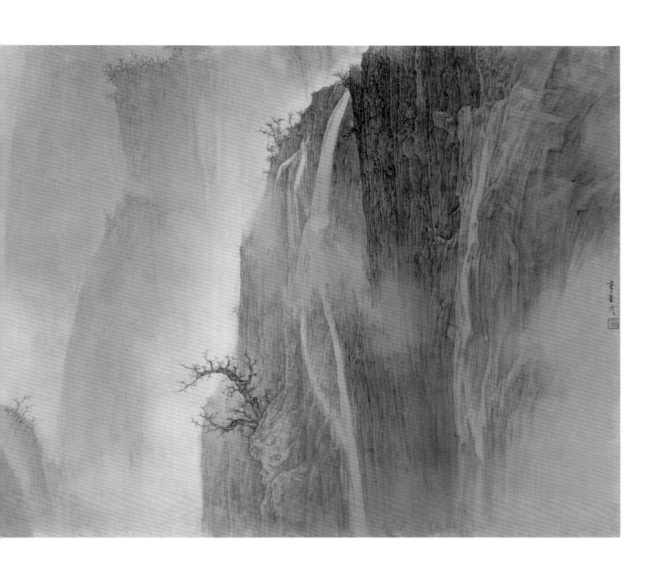

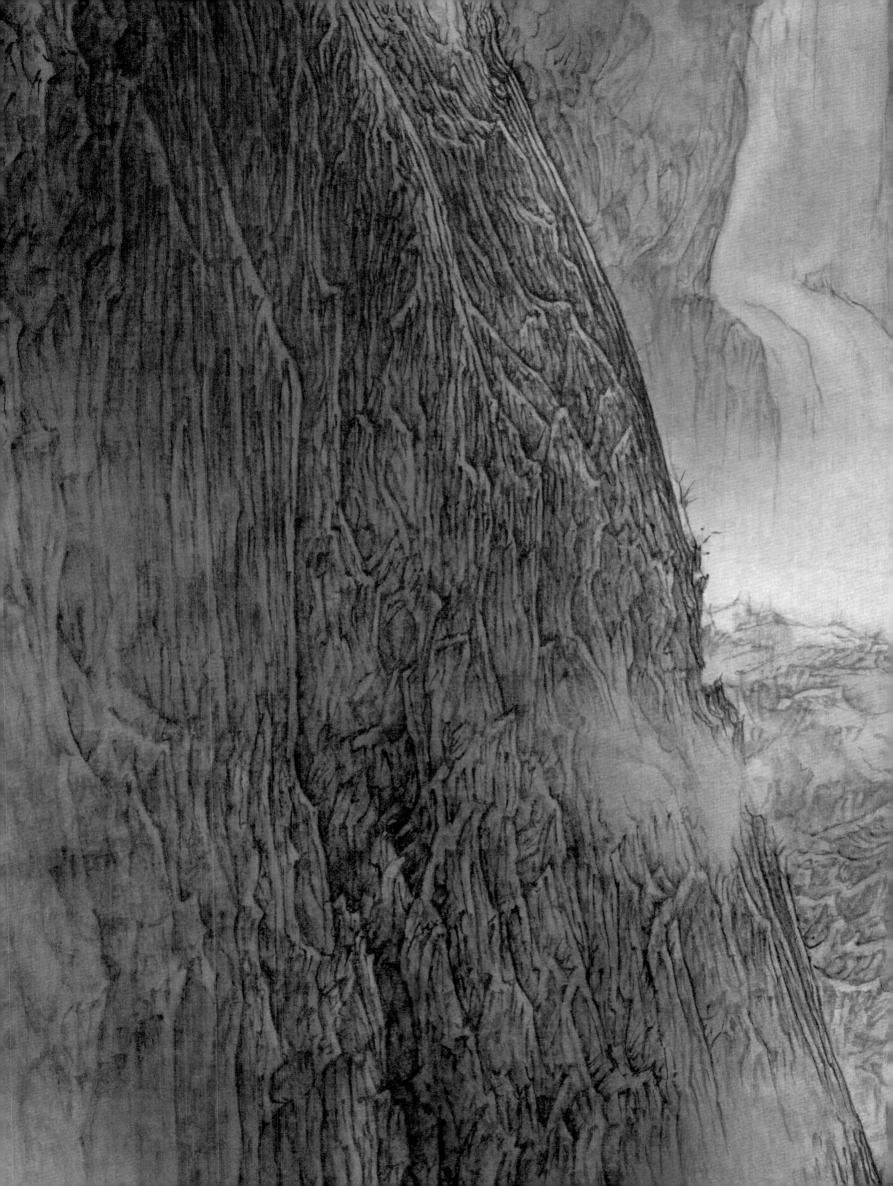

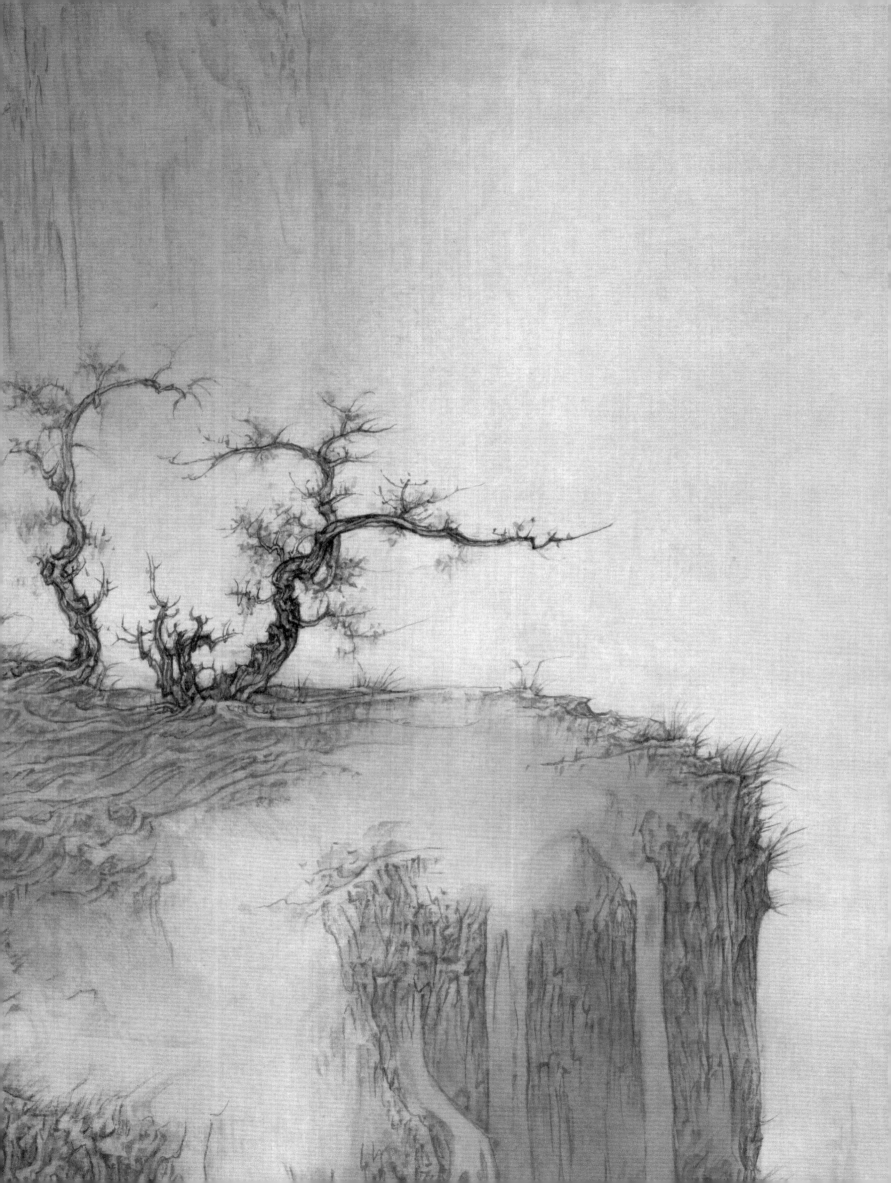

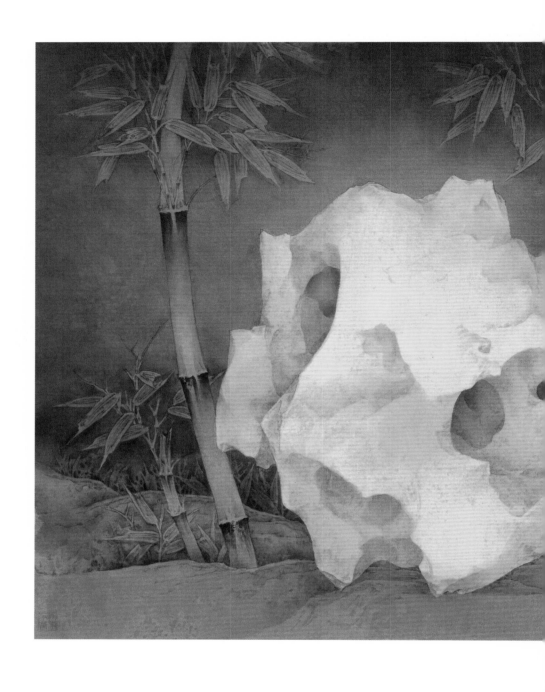

7
Rock in Moonlight II -
Taihu Rock by Moonlight
Ink and colour on silk
Dimensions: 64.5cm by 114.5cm

Signed: Li Huayi
Artist's seals: Taolibuyan *(left)*
Li Huayi yin *(right)*

月下石 二 月影竹石
絹本設色水墨
落款：李華弌
鈐印兩方：
左幅：桃李不言
右幅：李華弌印

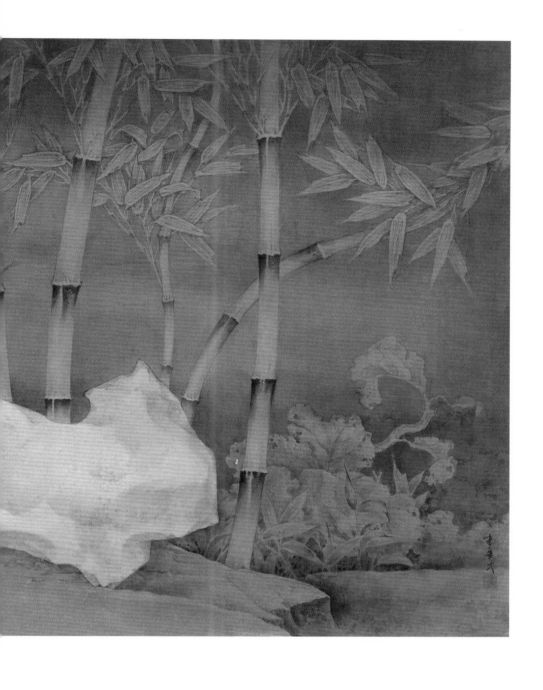

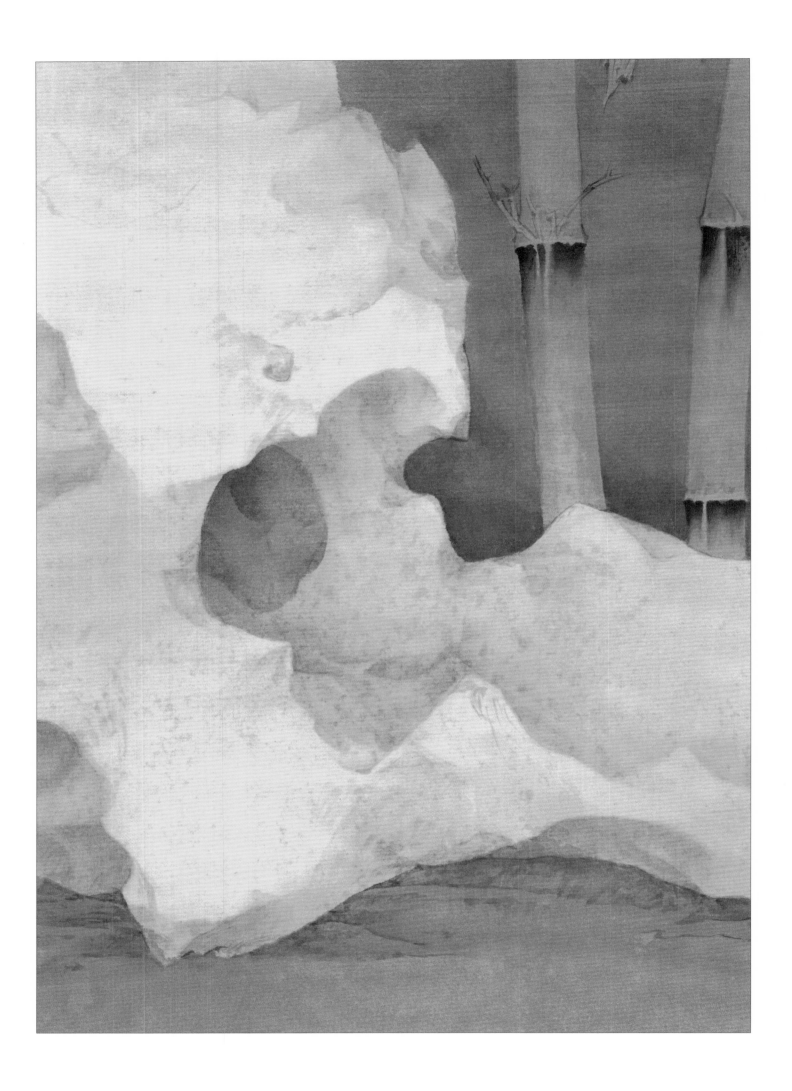

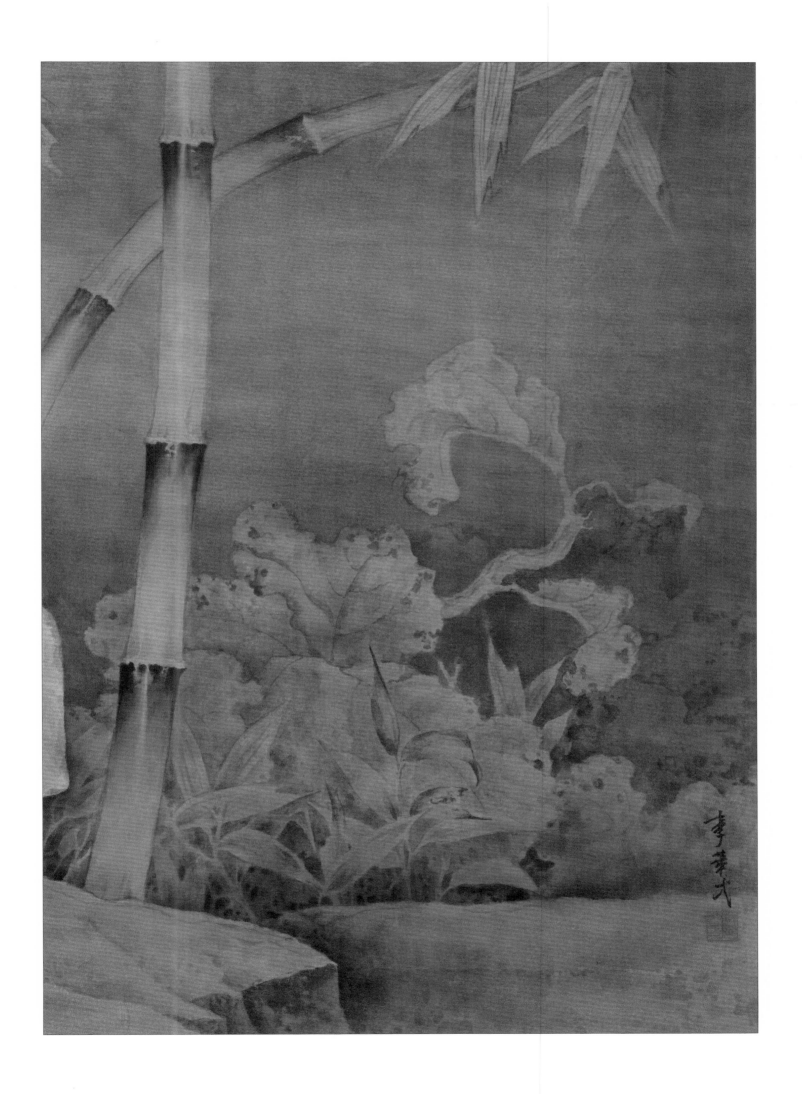

8
Rock in Moonlight III - *Rock and Bamboo*
Ink and colour on silk
Dimensions: 157.0cm by 81.0cm

Signed: Li Huayi
Artist's seal: Li Huayi

月下石 三　蒼竹秀石
絹本設色水墨
落款：李華弌
鈐印：李華弌

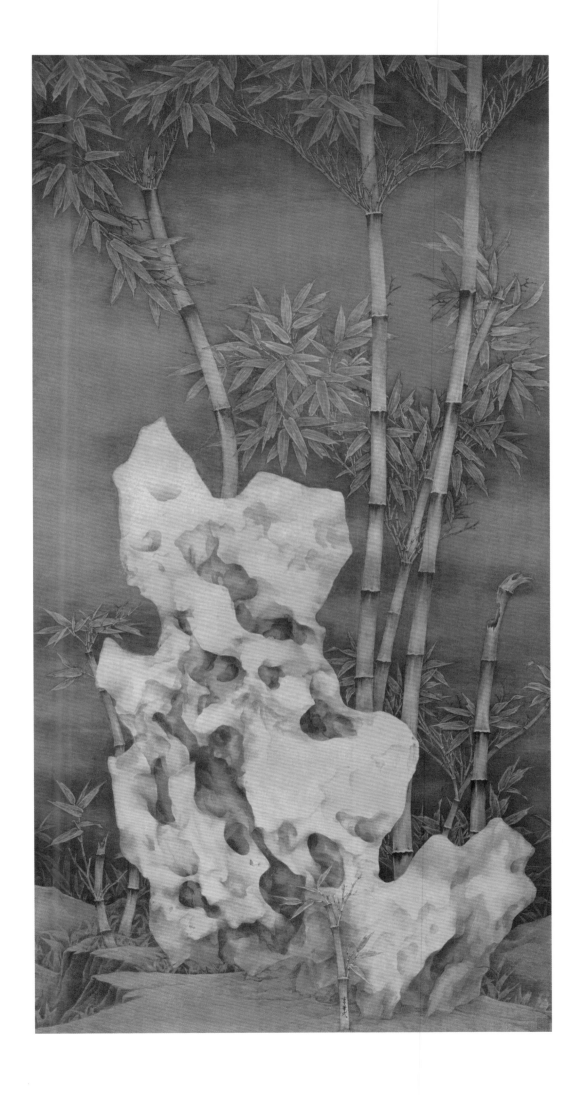

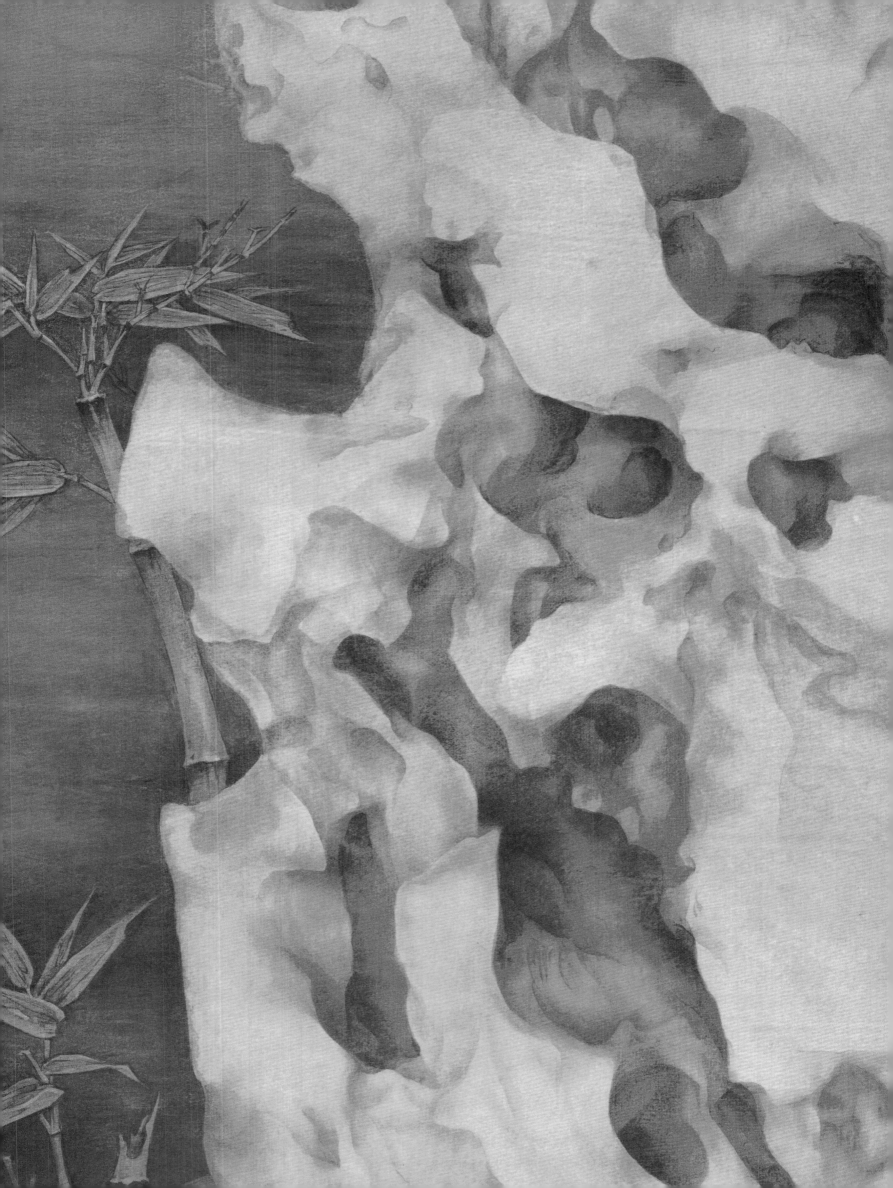

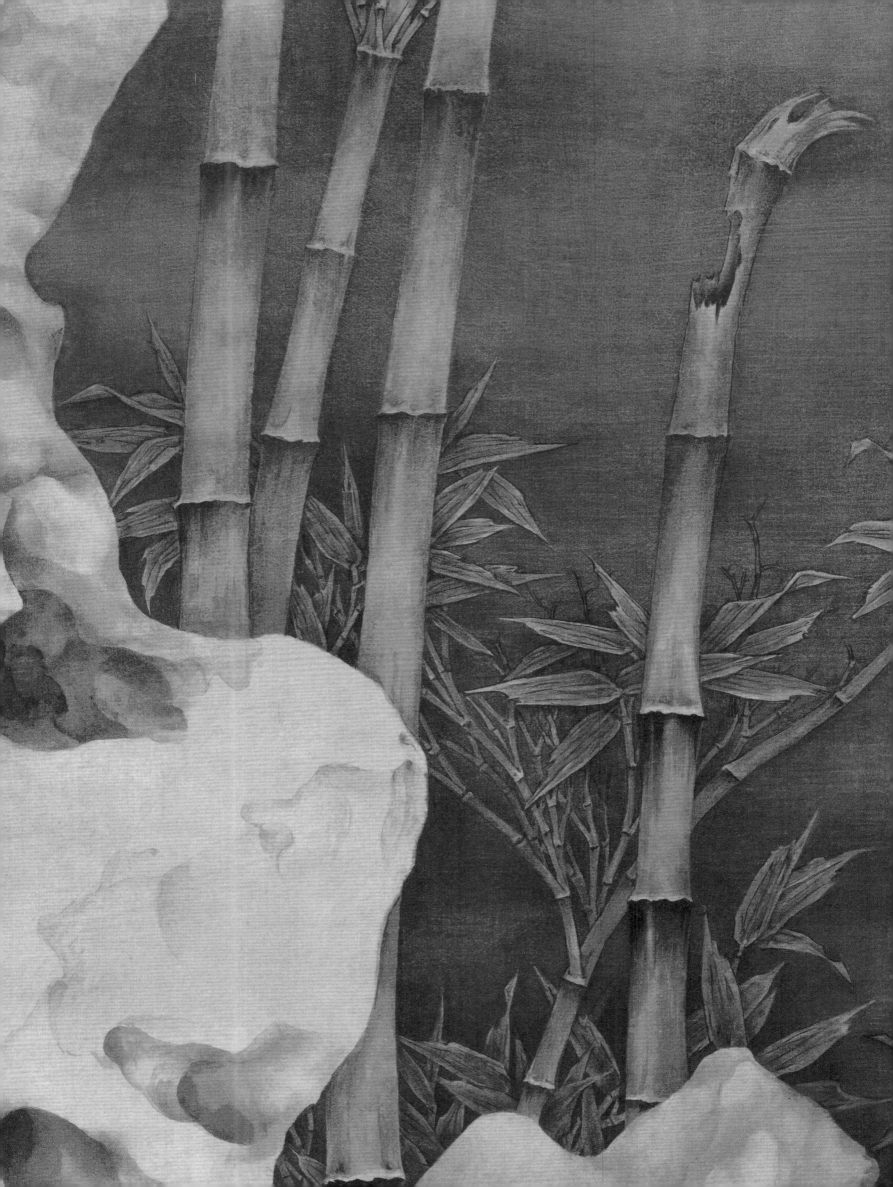

Paintings by Li Huayi are now in the following museum collections :

李华弌画作现收藏于以下博物馆：

Art Institute of Chicago, Chicago
Asian Art Museum of San Francisco, San Francisco
Cleveland Museum of Art, Cleveland
Harvard University Art Museums, Cambridge
Museum of Fine Arts, Boston
Spencer Museum of Art, University of Kansas, Lawrence
College of Wooster Art Museum, Wooster
Honolulu Museum of Art, Honolulu

美国芝加哥藝術博物館
美国舊金山亞洲藝術博物館
美国克里夫蘭藝術博物館
美国哈佛大學藝術博物館
美国波士頓藝術博物館
美国堪薩斯大學藝術博物館
美国伍斯特艺术博物馆
美国檀香山藝術学院博物馆

Works of art purchased from Eskenazi Ltd.
London, are now in the following museum collections:

Ackland Art Museum, North Carolina
Arita Porcelain Park Museum, Saga
Art Gallery of New South Wales, Sydney
Art Gallery of South Australia, Adelaide
Art Institute of Chicago, Chicago
Arthur M. Sackler Gallery, Washington, DC
Art Museum, Princeton University, Princeton
Ashmolean Museum, Oxford
Asia House, Mr and Mrs John D Rockefeller 3rd
Collection, New York
Asian Art Museum of San Francisco, San Francisco
Asian Civilisations Museum, Singapore
Baltimore Museum of Art, Baltimore
Birmingham Museum of Art, Alabama
British Museum, London
Brooklyn Museum, New York
Chang Foundation, Taibei
Chung Young Yang Embroidery Museum, Sookmyung
Women's University, Seoul, Korea
Cincinnati Art Museum, Cincinnati
Cleveland Museum of Art, Cleveland
Columbus Museum of Art, Columbus
Corning Museum of Glass, Corning
Dallas Museum of Fine Arts, Dallas
Dayton Art Institute, Dayton
Denver Art Museum, Denver
Didrichsen Art Museum, Helsinki
Fitzwilliam Museum, Cambridge
Flagstaff House Museum of Teaware, Hong Kong
Freer Gallery of Art, Washington, DC
Fuji Art Museum, Tokyo
Hagi Uragami Museum, Hagi
Hakone Museum of Art, Hakone
Harvard Art Museums, Cambridge, Massachusetts
Hetjens Museum, Düsseldorf
Hong Kong Museum of Art, Hong Kong
Honolulu Museum of Art, Honolulu
Idemitsu Museum of Arts, Tokyo
Indianapolis Museum of Art, Indianapolis
Israel Museum, Jerusalem
Istituto Italiano per il Medio ed Estremo Oriente, Rome
Kimbell Art Museum, Fort Worth
Kuboso Memorial Museum, Izumi City, Osaka
Los Angeles County Museum, Los Angeles
Louvre Abu Dhabi, Abu Dhabi
Matsuoka Museum of Art, Tokyo
Metropolitan Museum of Art, New York
Miho Museum, Shigaraki
Minneapolis Institute of Arts, Minneapolis
MOA Museum of Art, Atami
Musée Ariana, Geneva
Musée des Arts Asiatiques, Nice
Musée Guimet, Paris

Musées Royaux d'Art et d'Histoire, Brussels
Museum für Kunst und Gewerbe, Hamburg
Museum für Lackkunst, Münster
Museum für Ostasiatische Kunst, Berlin
Museum für Ostasiatische Kunst, Cologne
Museum of Decorative Art, Copenhagen
Museum of Fine Arts, Boston
Museum of Fine Arts, Houston
Museum of Islamic Art, Doha
Museum of Oriental Ceramics, Osaka
Museum Rietberg, Zurich
National Gallery of Australia, Canberra
National Gallery of Canada, Ottawa
National Gallery of Victoria, Melbourne
National Museum, Singapore
National Museum, Tokyo
Nelson-Atkins Museum of Art, Kansas City
Nezu Institute of Fine Arts, Tokyo
Norton Simon Museum of Art at Pasadena, Pasadena
Östasiatiska Museet, Stockholm
Royal Ontario Museum, Toronto
State Administration of Cultural Heritage, Beijing
St. Louis Art Museum, St. Louis
Seattle Art Museum, Seattle
Shanghai Museum, Shanghai
Speed Art Museum, Louisville
Toguri Museum of Art, Tokyo
Tsui Museum of Art, Hong Kong
Victoria & Albert Museum, London
Virginia Museum of Fine Arts, Richmond
Worcester Art Museum, Worcester

Previous Exhibitions

March 1972	Inaugural exhibition Early Chinese ceramics and works of art.
June 1972	Georges Rouault, an exhibition arranged by Richard Nathanson.
June 1973	Ancient Chinese bronze vessels, gilt bronzes and early ceramics.
November 1973	Chinese ceramics from the Cottle collection.
December 1973	Japanese netsuke formerly in the collection of Dr Robert L Greene.
June 1974	Early Chinese ceramics and works of art.
November 1974	Japanese inrō from the collection of E A Wrangham.
May 1975	Japanese netsuke and inrō from private collections.
June 1975	Ancient Chinese bronzes from the Stoclet and Wessén collections.
June 1976	Chinese jades from a private collection.
June 1976	Michael Birch netsuke and sculpture.
June 1976	Japanese netsuke and inrō from private collections.
June 1977	Ancient Chinese bronze vessels, gilt bronzes and sculptures; two private collections, one formerly part of the Minkenhof collection.
June 1978	Ancient Chinese sculpture.
June 1978	Michael Webb netsuke.
June 1978	Eighteenth to twentieth century netsuke.
June 1979	Japanese netsuke from private collections.
June 1980	Japanese netsuke from private collections and Michael Webb netsuke.
July 1980	Ancient Chinese bronzes and gilt bronzes from the Wessén and other collections.
December 1980	Chinese works of art from the collection of J M A J Dawson.
October 1981	Japanese netsuke and inrō from the collection of Professor and Mrs John Hull Grundy and other private collections.
December 1981	Ancient Chinese sculpture.
October 1982	Japanese inrō from private collections.
November 1983	Michael Webb, an English carver of netsuke.
October 1984	Japanese netsuke, ojime, inrō and lacquer-ware.
June 1985	Ancient Chinese bronze vessels, gilt bronzes, inlaid bronzes, silver, jades, ceramics – Twenty five years.
December 1986	Japanese netsuke, ojime, inrō and lacquer-ware.
June 1987	Tang.
June 1989	Chinese and Korean art from the collections of Dr Franco Vannotti, Hans Popper and others.
November 1989	Japanese lacquer-ware from the Verbrugge collection.
December 1989	Chinese art from the Reach family collection.
May 1990	Japanese netsuke from the Lazarnick collection.
June 1990	Ancient Chinese sculpture from the Alsdorf collection and others.
November 1990	The Charles A Greenfield collection of Japanese lacquer.
June 1991	Inlaid bronze and related material from pre-Tang China.
November 1992	Japanese lacquer-ware – recent acquisitions.
December 1992	Chinese lacquer from the Jean-Pierre Dubosc collection and others.
June 1993	Early Chinese art from tombs and temples.
June 1993	Japanese netsuke from the Carré collection.
June 1994	Yuan and early Ming blue and white porcelain.
June 1995	Early Chinese art: 8th century BC-9th century AD.
October 1995	Adornment for Eternity, loan exhibition from the Denver Art Museum.
June 1996	Sculpture and ornament in early Chinese art.
November 1996	Japanese inrō and lacquer-ware from a private Swedish collection.
March 1997	Ceramic sculpture from Han and Tang China.
June 1997	Chinese Buddhist sculpture.
June 1997	Japanese netsuke, ojime and inrō from the Dawson collection.
November 1997	Japanese netsuke – recent acquisitions.
March 1998	Animals and animal designs in Chinese art.

June 1998	Japanese netsuke, ojime and inrō from a private European collection.
November 1998	Chinese works of art and furniture.
March 1999	Ancient Chinese bronzes and ceramics.
November 1999	Ancient Chinese bronzes from an English private collection.
March 2000	Masterpieces from ancient China.
November 2000	Chinese furniture of the 17th and 18th centuries.
March 2001	Tang ceramic sculpture.
November 2001	Chinese ceramic vessels 500 – 1000 AD.
March 2002	Chinese Buddhist sculpture from Northern Wei to Ming.
November 2002	Two rare Chinese porcelain fish jars of the 14th and 16th centuries.
March 2003	Chinese works of art from the Stoclet collection.
November 2003	Song: Chinese ceramics, 10th to 13th century.
March 2004	Chinese Buddhist figures.
November 2004	A selection of Ming and Qing porcelain.
March 2005	Ancient Chinese bronzes and sculpture.
November 2005	Song ceramics from the Hans Popper collection.
March 2006	A selection of early Chinese bronzes.
June 2006	Recent paintings by Arnold Chang.
November 2006	Chinese porcelain from the 15th to the 18th century.
March 2007	Song: Chinese ceramics, 10th to 13th century (*part 3*).
November 2007	Mountain landscapes by Li Huayi.
March 2008	Chinese sculpture and works of art.
October 2008	Chinese ceramics and stone sculpture.
October 2009	Seven classical Chinese paintings.
March 2010	Trees, rocks, mist and mountains by Li Huayi.
November 2010	Fiftieth anniversary exhibition: twelve Chinese masterworks.
March 2011	Early Chinese metalwork in gold and silver; works of art of the Ming and Qing dynasties.
November 2011	Chinese huanghuali furniture from a private collection.
November 2011	The twelve animals of the zodiac by Li Huayi.
November 2012	Qing porcelain from a private collection.
October 2013	Junyao.
October 2013	Bo Ju Gui: an important Chinese archaic bronze.